RIVER FORTH
FROM SOURCE TO SEA

Richard Happer & Mark Steward

AMBERLEY

First published 2015

Amberley Publishing
The Hill, Stroud, Gloucestershire, GL5 4EP
www.amberley-books.com

ISBN 978 1 4456 4884 2 (print)
ISBN 978 1 4456 4885 9 (ebook)

British Library Cataloguing in Publication Data.
A catalogue record for this book is available from the British Library.

Typesetting by Amberley Publishing.
Printed in Great Britain.

CONTENTS

ACKNOWLEDGEMENTS

I'd like to thank Elizabeth Teape at the Deanston Distillery. Also my mother and father, for all those sunny family days in North Berwick enjoying all that the firth had to offer – here's to sea, sun (sometimes), sand, daft dogs, world-class putting, Becker winning Wimbledon and the outdoor swimming pool by the harbour. By God, that was barry.

1

BEN LOMOND AND THE TROSSACHS

There are many things to be amazed at on the summit of Ben Lomond. The cleaved sapphire of the loch below you, its blue sheen flecked by tiny white imperfections made by scudding boats beneath the hunched shoulders of the gang-like Arrochar Alps. Millions of years of geology lie at your feet: here the Highland Boundary Fault divides the country's mountainous north from the rolling south. To the west, the crumpled labyrinth of lochs and forests that is the Trossachs. And perhaps the most astonishing thing of all: how those loons in flip-flops and St Mirren tops even made it up here.

You may also notice that the hill you have just climbed has a ridge – not precipitous, but clear enough. So, leave the Duke of Edinburgh kids to their Primula sandwiches and walk a little way back down that stony spine. Find a particularly ridgy spot and stand on it, legs athwart the rocky crest, and look south. Should it be a wet day (a rare occasion, I know, but use your imagination) then the raindrops that fall by your right foot will end up merrily washing the seals in the Firth of Clyde on Scotland's west coast. The drops that hit the heather by your left foot will splash under the Forth Bridge and be dived into by hungry gulls peeling off the Bass Rock on the country's eastern seaboard.

It might seem odd that Ben Lomond, for generations of Glaswegians the beacon that drew them north to adventure, is actually the source of the waters that run past Edinburgh. But we're not going to get all parochial; however you look at it, this is a beautiful place to be born.

The Source of the Forth

How do you determine the source of a river? The obvious answer would be to travel from the mouth to the most distant headwater. Measured like this, the longest tributary of the River Forth is actually what we call the River Teith, and it starts its life on the

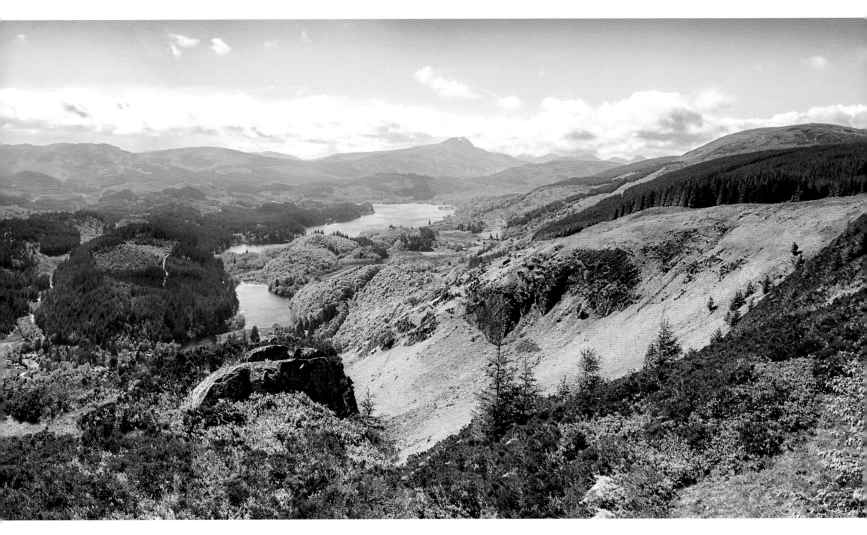

The lochs of the Trossachs and Ben Lomond – the origin of the Forth.

Munros just south of Crianlarich! However, history and local custom have decided that the shorter branch, which rises from Loch Ard and joins the Teith just west of Stirling, is the one that takes the name of the wide river estuary that meets the sea past Edinburgh. To stop the Teith feeling like an older brother usurped by an impossibly cute younger sibling, we shall deal with this noble stream in its own chapter. (Out of interest, the same situation is the case with the Mississippi and the Missouri in the USA. The tributary, the Missouri, has longer headwaters than the 'main' river, the Mississippi.)

So, the River Forth officially rises in Loch Ard in the Trossachs, the wild and woolly area of jumbled hills and lochs some 19 miles west of Stirling. ... Except it doesn't. A quick look at Ordnance Survey sheet 56 shows you that Loch Ard is replenished by the Water of Chon, which flows from Loch Dhu, a puddle that fronts the larger Loch Chon. That body of water is fed by the numerous streams tumbling down Beinn Uamha, just north of Ben Lomond. These, then, are the true source of the River Forth. It's also worth noting that the Duchray Water, a tributary just to the west, extends its fingers right round to grapple the northern slopes of Ben Lomond. The overall picture is that, unlike the Clyde's single source in the Lowther hills, the Forth is fed by the myriad waters that tumble through the crumpled wonderland that is the Trossachs.

The Trossachs

'The Highlands in miniature' is how the wild glens and sparkling lochs between Callander and Aberfoyle are often termed. ('Trossachs' itself means 'bristled territory' in Gaelic.) It's a description that applies to the roads as well as the scenery; despite the area's proximity to Stirling, its crumpled hills, narrow passes and full rivers long made this a hard part of the world to get to. And when you did reach it, the place was inhabited by some very grumpy locals. It seems hard to believe, as you cruise smoothly into the Trossachs along a well-maintained A-road, but just over 150 years ago this was bandit country. Until the Trossachs Inn was built in 1852, the only accommodation in the area was farmer James Stewart's pig byre. He'd happily cram sixty paying guests into rooms that were no better than the dung-strewn stalls. We'll never look down our noses at a B&B again ...

From the seventeenth to the nineteenth centuries the trade in cattle reared in the Highlands was very important to Scotland's economy. The cattle would be sold in the Lowlands at fairs or 'trysts' and the animals had to be walked all the way there along 'drove roads'. One drove road from Tyndrum and Crianlarich came along Loch Katrine and through the Trossachs. The gatherings of men and animals, the money and the thieves, all made trysts extremely wild and often dangerous occasions.

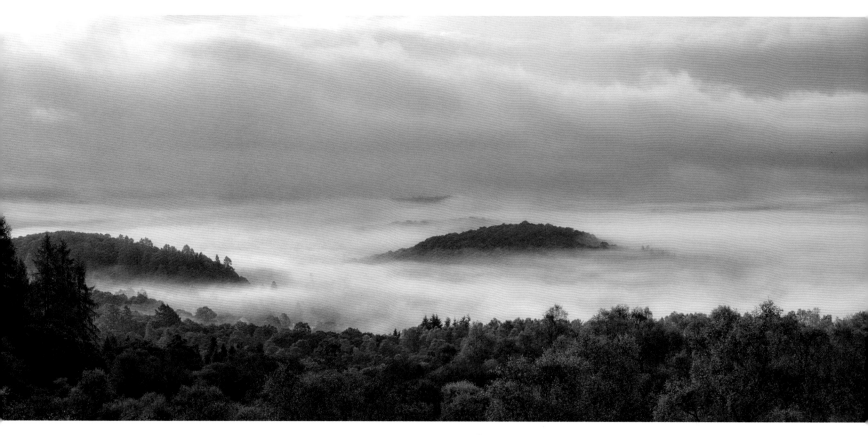

Mist turns the Fairy Knowe near Aberfoyle into a mystical island.

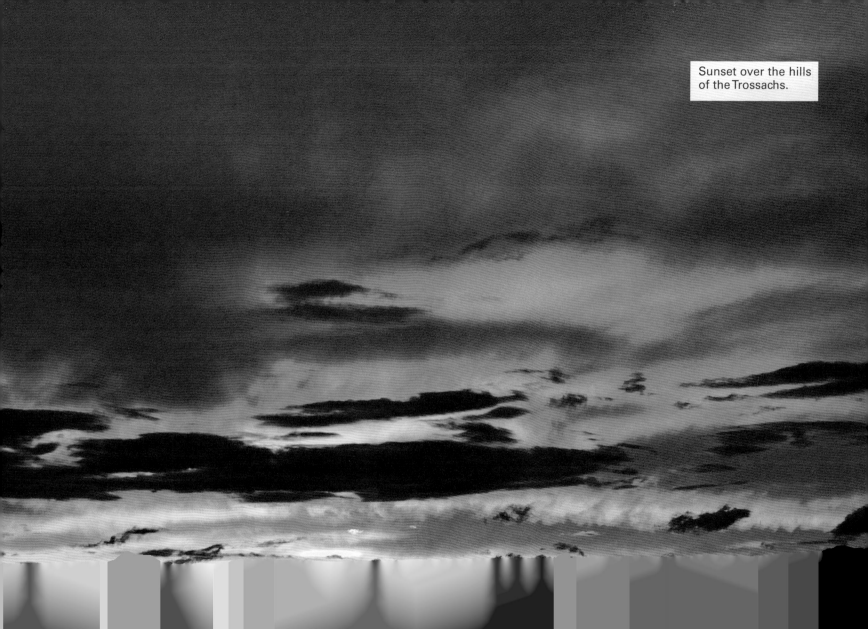

Sunset over the hills of the Trossachs.

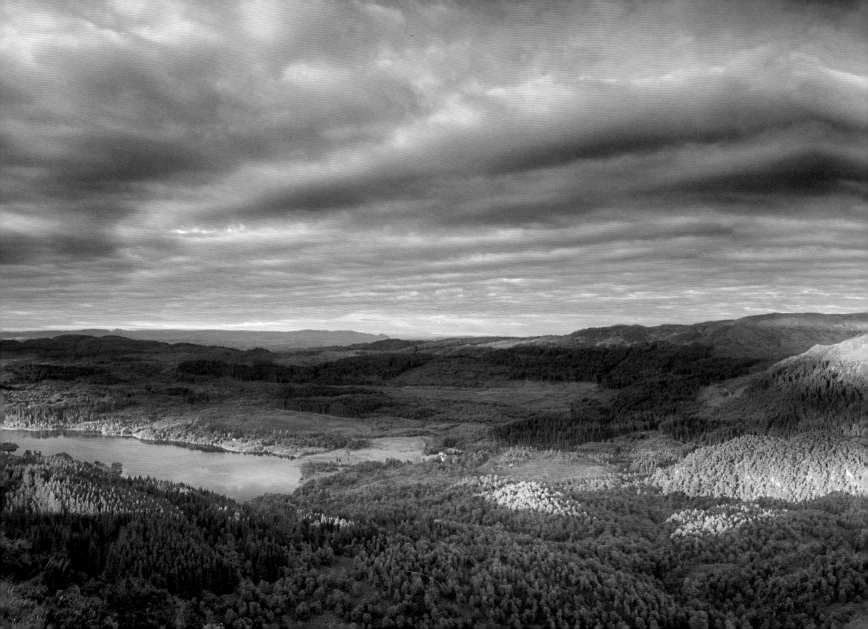

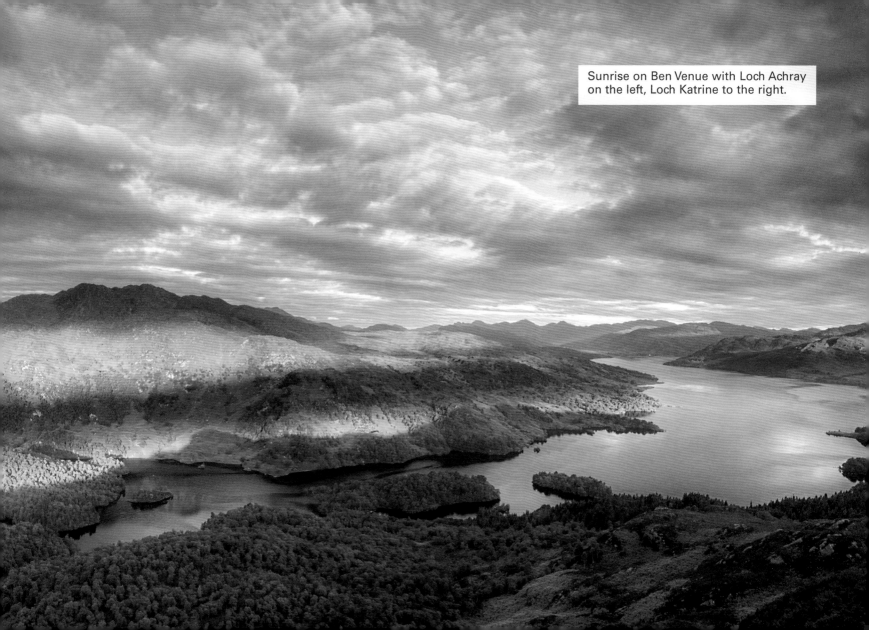

Sunrise on Ben Venue with Loch Achray on the left, Loch Katrine to the right.

The romantic beauties of the area were first publicised by the Reverend Dr Robertson, who in the late eighteenth century described the Loch Katrine and Loch Achray area as 'a tumultuous confusion of little rocky eminences, all of the most fantastic and extraordinary forms, everywhere shagged by trees and shrubs'. Sir Walter Scott later visited the Trossachs and was so taken with this area that he wrote his epic poem *The Lady of the Lake* (1810) about a lass who lives hereabouts. This work was a phenomenon – the first international blockbusting bestseller. He also set his famous novel *Rob Roy* here. It's no exaggeration to say that together they put the Trossachs on the map and Scott's writing virtually created the concept of Scottish tourism. The Trossachs became a haven for those seeking wild beauty, with Wordsworth, Coleridge and many other famous artists also visiting the area.

Today the towns in the Trossachs might seem cut from the same cloth: they all have a river, wooded hills behind, touristy shops and a faint air of romantic sadness, but each has its own unique and interesting story, and they are worth getting to know personally.

Loch Katrine

Loch Katrine really is a glorious spot, even with the coachloads of tourists that arrive daily. The name comes from *cateran*, an ancient word for cattle thief. The most famous of them all, Rob Roy MacGregor, was born at Glengyle House at the northern end of the Loch.

As well as looking beautiful, Loch Katrine is very useful: it supplies most of Glasgow's drinking water via two enormous conduits that run 26 miles to Milngavie. No oil-fired vessels are allowed on the waters, to protect the good people of Glasgow from pollution, so the steamship *Sir Walter Scott* runs on eco-friendly biodiesel. It was built in 1899 at Dumbarton, when the Clyde was the biggest shipyard in the world, and has been idling along this loch pretty much ever since. If you fancy giving your legs a stretch, you can take bikes on the boat (book at busy times) to Stronachlachar and cycle back along the traffic-free road that hugs the northern shore.

Aberfoyle

The young Forth shakes itself free from Loch Ard, the last of the Trossachs lochs, and sets out on its life as a young river. After a cheerful mile it chatters past the town of Aberfoyle. In the eighteenth century Aberfoyle was just a handful of low stone houses clustered around an old church. A few quarrymen earned a living hewing slate from the hills, living up on the slopes beside the remote quarry in a wooden bunkhouse. However, when the railway arrived in 1882 production of the Aberfoyle quarries increased

dramatically. Aberfoyle slate was renowned for its superior quality and was soon keeping the rain out of houses all over the country, as well as in far-flung corners of the British Empire. The wealth brought by the quarries saw the town expand with several streets of grand Victorian villas and hotels.

The railway's heyday didn't last long. Its passenger business was lost to charabancs from the 1920s onwards, and the arrival of cheaper, imported slate also saw freight traffic dwindle. The Aberfoyle branch line completely closed in 1959. The old station is now a car park, but the old line can be walked as far as Buchlyvie, a pleasant 6 miles to the south-east. Surrounding Aberfoyle is the Queen Elizabeth Forest Park, a vast forestry commission plantation that doubles as a prime destination for cyclists, walkers and bird watchers.

Roll Away the Stone

Aberfoyle also goes down in history as the hiding place of the Stone of Scone. Also known as the 'Stone of Destiny', this 26-inch-long lump of sandstone was the fabled coronation seat of the ancient Scottish kings. It had lain under the coronation chair in Westminster Abbey since 1296 when it was taken south

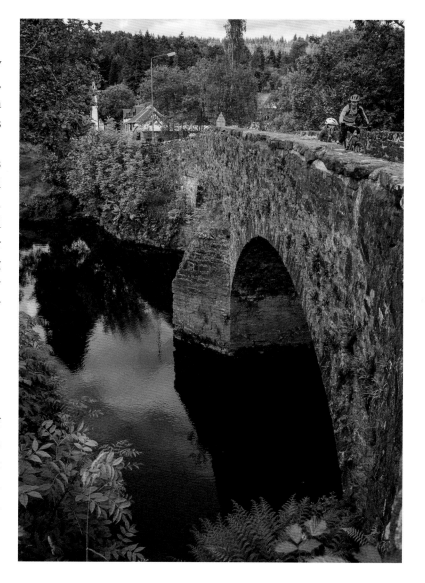

An old bridge over the young Forth at Aberfoyle.

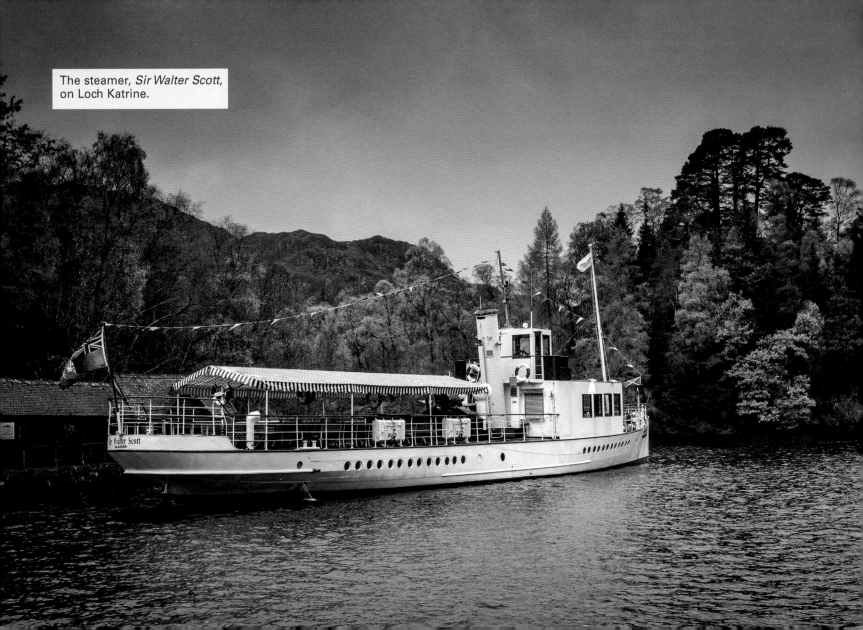

The steamer, *Sir Walter Scott*, on Loch Katrine.

You can practically
sense the trout...

Loch Venacher in autumn.

by King Edward I to symbolise his conquests in Scotland. Every English and British monarch since then has sat above it to be crowned. On Christmas Day in 1950 four mischievous young Scottish nationalists stole the stone from the abbey and drove it north. After four months in hiding – some of which time was spent in the Covenanters Inn in Aberfoyle – the stone was placed in Arbroath Abbey (where the famous Declaration of Scottish Independence was written in 1320) draped in a saltire. It was later returned to Westminster. In 1996 the roving rock was placed in Edinburgh Castle, again as a political gesture, and there it will stay; except for a city break back down to London when it comes time to crown King Charles III.

Brig o' Turk

Pass through here when the mist is on the waters and Brig o' Turk can seem like it's lost in time. Stop for a cuppa in its old-fashioned tearoom and you might recognise it from the 1959 film *The 39 Steps*. It's worth noting that the village's name means 'Bridge of the Wild Boar' (*torc* is wild boar in Gaelic) rather than Bridge of the Turkish Person. In the mid-nineteenth century this little place was the scene for a scandal that shocked Victorian society: the love triangle between the famed critic John Ruskin, his wife Effie Gray and the painter John Everett Millais. Despite the blood-tingling romantic wildness of the scenery, Ruskin couldn't bring himself to consummate his marriage to Effie. He cited 'certain circumstances in her person which completely checked' his passion. Understandably, she fell into the arms of Millais, for whom she was modelling, and they later married.

Above: Travel back in time in the Trossachs.

Right: Another source of wetness.

All Things Damp and Wonderful

South-east of Aberfoyle is the flat, marshy area of land known as Flanders Moss. The eastern section of this is the largest natural raised bog in Europe. A raised bog is formed over many centuries when peat builds up in a shallow lake or marsh, producing a fragile and very beautiful ecosystem. The bog is a paradise for birds, including snipe and stonechat. There are carnivorous plants, great mats of sphagnum moss and peat hummocks that quake and wobble disconcertingly under your feet. In hidden gullies, adders and lizards bask undisturbed. The western section of the Moss was planted with conifers in the 1970s, but is now being returned to its original squelchy majesty.

Several tributaries of the Forth slouch across the peat bogs here, including the Goodie Water, which flows out of the Lake of Menteith. This is famously touted as the only lake in Scotland; its name is a twisting of 'laich' or 'low place'. However, pub quiz fans should know that the Lake of Menteith is really the only *natural* body of water so called, as there are also several *artificial* Scottish lakes: Pressmennan Lake, the Lake of the Hirsel, Cally Lake, Smeaton Lake and Lake Louise in the grounds of Skibo Castle. These were presumably christened by English landowners trying to be difficult. All of the country's other bodies of water are termed lochs.

Above: Flanders Moss in summer ...

Below: ... and winter.

The Lake of Menteith has a few islands, one of which is home to Inchmahome Priory. Founded by Augustinian canons in the thirteenth century, the priory enjoys a truly serene setting. The 4-year-old Mary, Queen of Scots, was sent here for protection when an English invasion looked likely. You can take a boat out to visit the priory in the summer. In winter, if it's cold enough, the shallow loch freezes practically solid and the Lake of Menteith becomes the Mecca of Scottish curling. The Grand Match, or Bonspiel, draws thousands of stone-skidders from all over the country. The last one was held in 1979 – winters obviously aren't what they used to be.

Geology of the Forth Valley

It's slow going for the River Forth after Flanders Moss. On a map, the river's path here looks like the wanderings of a Grassmarket drunk. It twists a little this way, that way, makes a little ground, then lurches violently sideways and turns back on itself almost in a circle. This is the carse: a very flat area of arable land lying between the Menteith Hills in the north and the Gargunnock Hills to the south. It is so flat and fertile because it is rich in sediment and was once the bottom of the ocean. In fact, waves once lapped the seashore at Aberfoyle.

Above: Curling has been cancelled today.

Below: Flat and fertile, this valley was once under the sea.

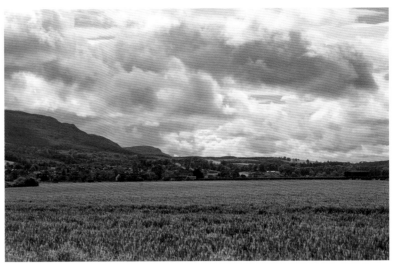

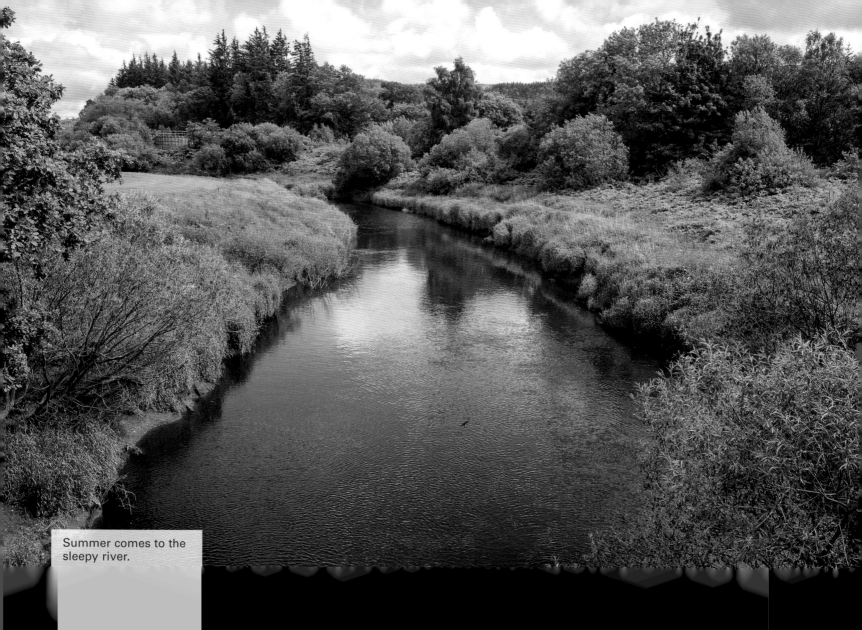

Summer comes to the sleepy river.

To understand the area's geography, we need to go back 18,000 years to when a vast icecap covered much of Scotland – even the Ochil Hills were buried under an ice sheet a kilometre thick. The climate later changed and around 13,500 years ago the ice began to melt. The Forth Valley had colossal amounts of debris dumped on it by melting glaciers.

After the ice melted, the land had less weight on it and so began to bounce back up, but the oceans now had more water in them and sea levels increased. There was something of a competition – land versus sea – but eventually the sea flooded the Forth Valley to a level 53 feet higher than today. Relative sea levels were highest 15,000 years ago and 7,000 years ago, and 'raised beaches' – flat shelves high up on coastal hillsides – from these times are visible today.

As recently as 6,500 years ago, the carse west of Stirling were banks of silt slowly rising above the waters of the estuary. When the bogs of the carse were drained in the eighteenth century, the skeletons of whales 82 feet long were exposed.

Climb any of the hills that edge the carse here and you'll find it easy to imagine this flat-bottomed valley as a long bay. The Ochil Hills were the high northern shore and Stirling's Abbey Craig and castle rock were tiny islands. Back to today, though, and the River Forth has finally staggered out of the carse to meet the River Teith just west of Stirling.

Above: A whole lot of lovely nothing.

Below: An old bridge near Gargunnock.

Rhododendrons on
the riverbank.

The slow-flowing river is almost all curves at this point.

THE COACH HOUSE

Not a bad spot to live,
we suppose.

2

THE RIVER TEITH

The River Forth runs for 29 miles to Loch Ard where it widens into an estuary, the Firth of Forth. The River Teith, its supposed tributary, is over twice as long – 70 miles – but doesn't get a firth of its own. Poor old Teith. Well, here's where we show this proud river the respect it deserves.

Seven Munros stand sentinel to Crianlarich and the innumerable streams that tumble down their southern rumps all end up in Loch Voil. This is the first gathering of the waters that will become the Teith. If Loch Voil lay in the Lake District, romantic poets would have written hundreds of odes to its beauty and every summer its shores would be lined with coaches nose to tail. Happily, however, it lies up a dead-end track in a glen that no one but anglers and walkers would even know is there. That means we can keep its serene waters, wooded banks and craggy hills to ourselves. At the loch's eastern end those innumerable streams have been focused into the River Balvaig, which begins its life by the village of Balquhidder. Here you'll find the grave of Scotland's famous

The wild hills behind Crianlarich, where the Teith is born.

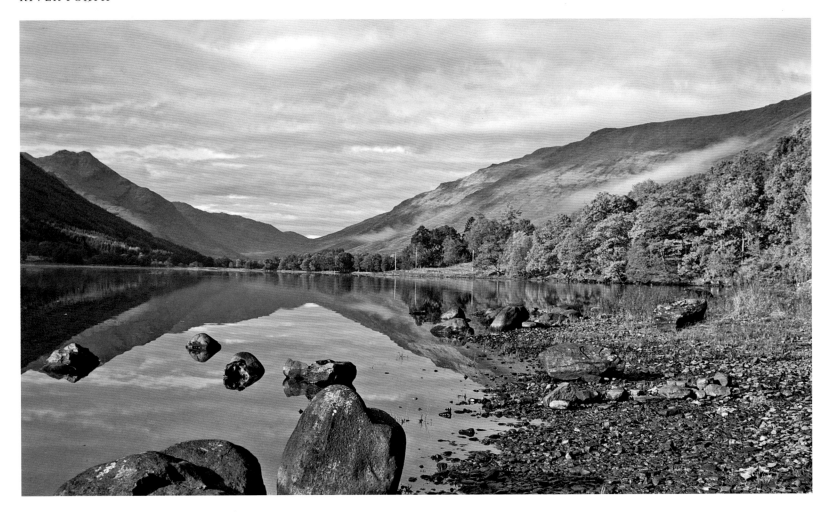

Loch Voil at peace on an autumn morning.

rebel outlaw Rob Roy MacGregor. He rests from his travails in the graveyard of the medieval village church.

As the Balvaig swings south it joins the bed of the former Callander and Oban Railway. This was one of the most spectacular railway lines in Scotland – and it was up against some pretty stiff competition – until a rockfall in Glen Ogle closed the line in 1965. You can still enjoy many of the line's views, though, as it forms part of the Rob Roy Way long-distance footpath.

The river now rolls past the caravan sites behind Strathyre and into snaking Loch Lubnaig, which then chicanes round the base of Ben Ledi. Fittingly, lùbnaig means 'crooked' in Gaelic. This loch's beauty used to be seriously impaired by fishermen who 'wild' camped on every patch of grass all weekend, filling themselves with Tennents lager and sawing down saplings to burn. Thankfully, this behaviour has now been controlled and formal but sympathetic visitor facilities built nearby.

The river now runs through the Pass of Leny, a rocky, heavily forested gulch, and thrashes itself to foam on the Falls of Leny. These are roaringly spectacular when in spate. The pace eases at Kilmahog and here the river is known as Garbhe Uisge.

Meanwhile, far up Beinn a Choin, at the northern end of Loch Lomond, a few small streams chatter down to the east and fill Loch Katrine. Running out from this is the Achray Water, which pools into Loch Achray and then, just after Brig o' Turk, Loch Venacher. It runs on, now as the Eas Gobhain, to join the Garbhe Uisge and the two of them stroll hand in hand into Callander as the River Teith.

Callander

Callander is the largest town in the Trossachs and, for many driving up from the Central Belt, the gateway to the Highlands. That is, it's the last place to get petrol and a pie. Its string of outdoor shops are fairly ho-hum, but there's a famed chippy frequented by walkers and bikers alike, the best pie shop in the Western Hemisphere (Mhor Bread) and a brilliant hardware shop, Screw It (motto: 'If we don't have it, you don't need it'). The town is backed by Ben Ledi, a fine hill that's just shy of Munro status. Callander was the birthplace of the last person to be tried for the crime of witchcraft in the United Kingdom, amazingly in 1941. Helen Duncan was a medium, famous for producing 'ectoplasm' at seances – this was actually cheesecloth which she regurgitated. Duncan claimed to have been told by a spirit that a British ship had been sunk (the information was actually an intelligence leak). With U-boats attacking the Royal Navy and German bombs dropping on British soil, national tensions were high and the authorities were annoyed by her nonsense. She was tried under Section 4 of the Witchcraft Act 1735, covering fraudulent 'spiritual' activity, and jailed for nine months.

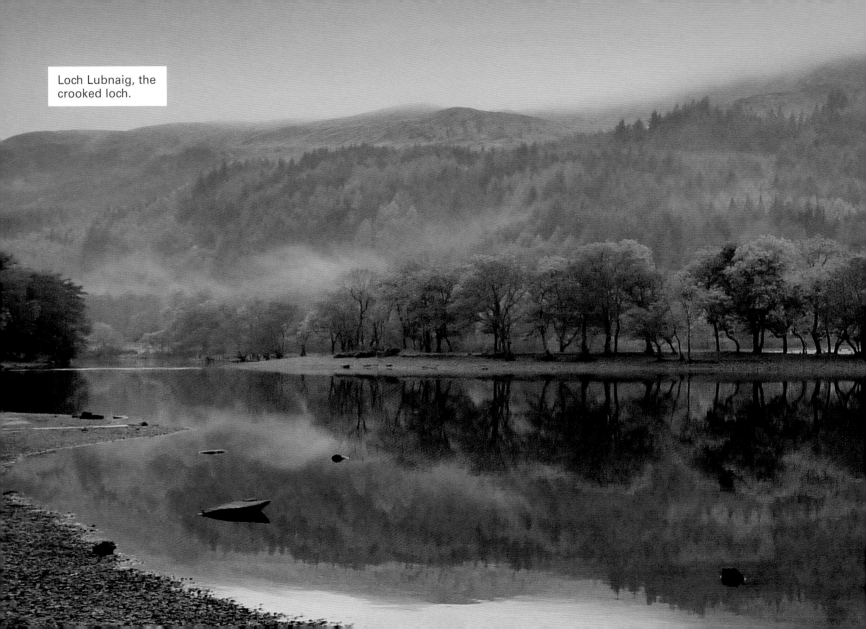

Loch Lubnaig, the crooked loch.

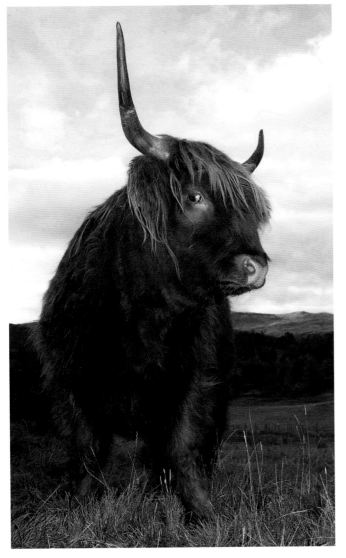

Doune

Scotland has bigger, grander, more romantic and lonelier fortifications, but Doune feels like the most authentic castle in the country. This very well-preserved fourteenth-century structure has been kept relatively unadorned inside. So there aren't many tapestries and gold dining sets to gawp at, but boy do you get a very real idea of what it was like to live in a place like this – flipping freezing, almost all the time. The great hall is an echoing cathedral-like chamber, while in the kitchen you can practically smell the boiling flesh being prepared for a great banquet. If it looks familiar, you were either a medieval baron in a previous life or you're a Monty Python fan – Doune starred as Castle Anthrax, Swamp Castle and Camelot in *Monty Python and the Holy Grail*. Make sure you rent an audio guide when you visit: Terry Jones provides the commentary on the tour. Oh, and the

Opposite left: 'Don't even think about it!' One of the highland bulls at Kilmahog.

Opposite right above: Leny Falls on a very calm day.

Opposite right below: About 16 feet from the main street, but a million miles away.

Above: Bracklinn Falls – a perfect place to ponder.

Below: The Teith is larger and faster than the Forth, which lies just 3 miles south of here.

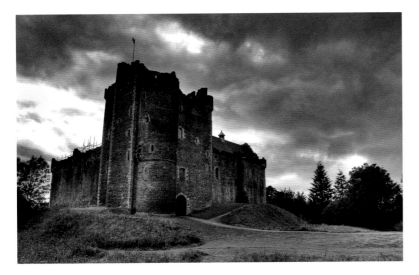

staff will cheerfully supply you with coconut shells should you forget to bring your own.

Right by the river, just outside Doune, is the Deanston Distillery. The distillery buildings started life in 1785 as a cotton mill designed by Sir Richard Arkwright, creator of the modern factory system and 'the Father of the Industrial Revolution'. Deanston Mill was an innovative operation from day one. When the Napoleonic Wars hoovered up much of the country's gold and silver coinage, Deanston came up with a simple solution: its own currency. The mill countermarked Spanish and French coins and paid workers with them.

Four large waterwheels powered the looms at Deanston. The biggest, nicknamed Hercules, was 36 feet and 6 inches in diameter, produced 300 horsepower and was the largest waterwheel in Europe. The colossal wheels were dismantled in 1949, but there is footage of them in operation on display at the distillery visitor centre.

The large, vaulted weaving shed – today the warehouse – has a cast-iron cupola roof that was insulated with soil to keep it at the ideal temperature for weaving cotton (80 °F) and to soften the noise of hundreds of looms clattering away inside. The soil-covered roof was also used by workers to plant vegetables.

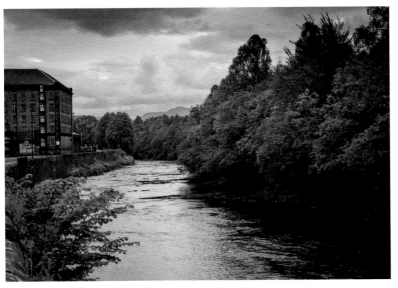

Above: Welcome to Castle Anthrax!

Below: The old mill buildings are now a distillery.

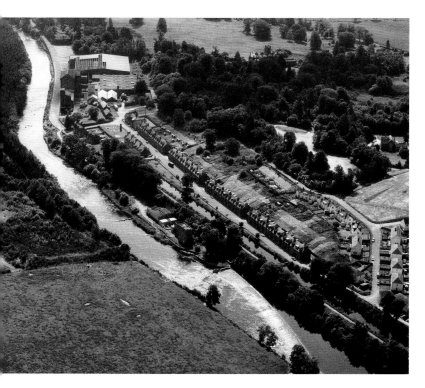

The weir, millworkers' houses and mill buildings are clearly visible in this aerial photograph.

The mill was still producing fabric 180 years after its foundation, until it finally closed in 1965. The buildings and the abundant supply of pure water from the River Teith made it an ideal location for a distillery and the site was converted within a year. Today the river delivers hydropower to the distillery through on-site generators, and Deanston is the only distillery in Scotland to be self-sufficient in electricity.

Just off the Main Street in Doune, behind a black, wrought-iron gate, stands a modest but very historic building: the original Doune pistol factory. Thomas Caddell started making flintlock pistols at Doune in 1646, which he sold to nervous cattle men at local fairs. His workmanship soon became widely famous and Doune was the centre of a pistol-making industry that flourished for over a century. A Doune pistol can be recognised by several features: a ramshorn or scroll butt, a fluted barrel at the breech, an octagonal flared muzzle and intricate engraving and inlaying. Doune pistols were easy to draw and fire quickly. They were usually sold in pairs. You can see some of its gunsmiths' work in the National Museum in Edinburgh. Legend has it that a Doune pistol fired the first shot of the American War of Independence.

After Doune, the river runs south for a mile and then makes one of the most remarkable diversions in world geography. It divides around a small island, bends to the south-east, then leaves Scotland entirely and runs through an African grassland. Well, through the expansive grounds of Blair Drummond Safari

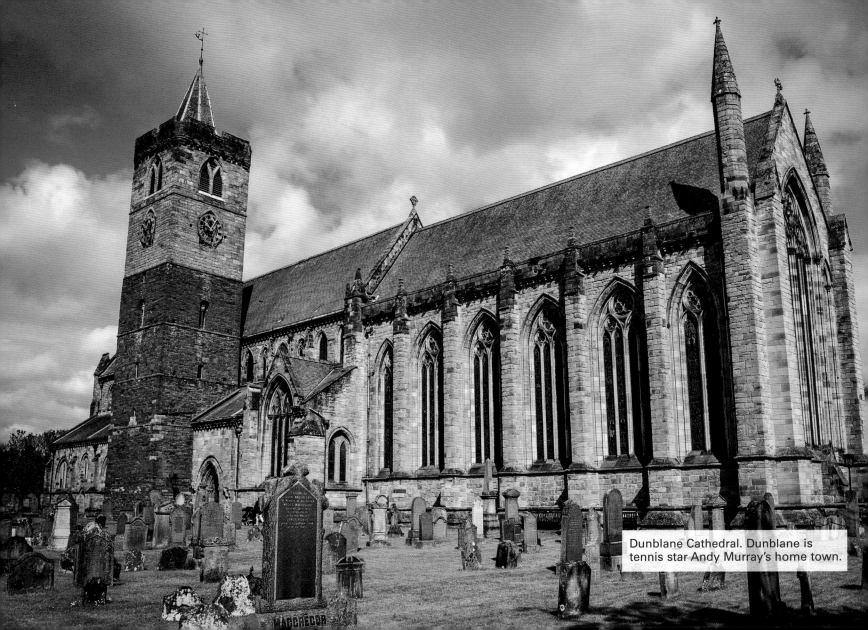

Dunblane Cathedral. Dunblane is tennis star Andy Murray's home town.

Park, but the lions don't know any different. Giraffes have been standing bemused in the Scottish drizzle since 1970. Much beloved by generations of schoolchildren, the park is also a happy place for several endangered species, including white rhinoceros and Bactrian camels. Other animals on show include Siberian tigers, lemurs, elephants and ostriches.

The next few miles of wooded banks and easy bends are often dotted with fishermen, and at this point it's easy to see how the river got its name from the Gaelic *Uisge Theamhich*, meaning 'quiet and pleasant water'. The Teith then quietly and pleasantly skirts the Stirling Agricultural Centre – one of the largest livestock auction marts in the country – and meets the Forth unseen behind a garden centre at a hamlet called, wonderfully, Drip.

The elegant old bridge at Doune.

Left: Go on, rub my tummy.

Below: Mr Forth, meet Mr Teith.

Opposite: Pleased to meet you, sir.

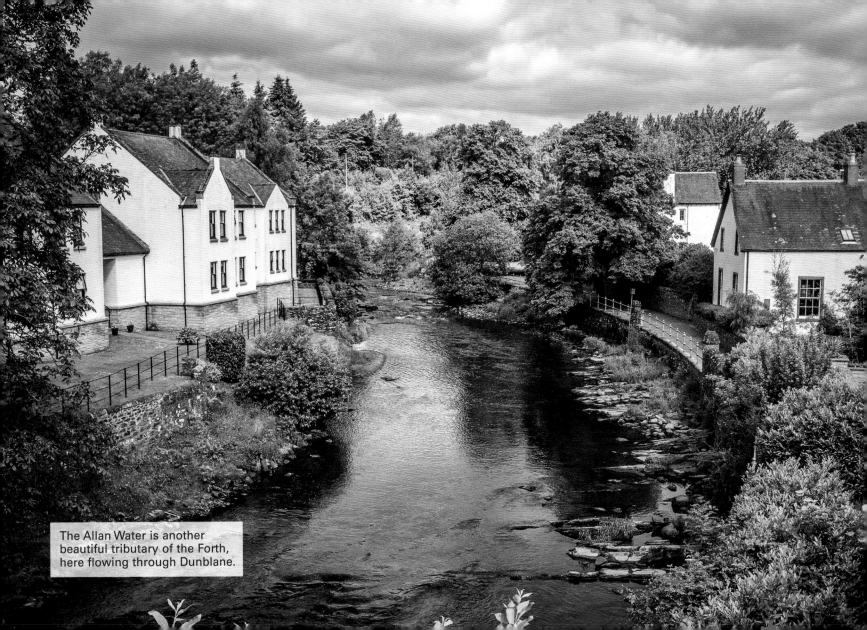

The Allan Water is another beautiful tributary of the Forth, here flowing through Dunblane.

3

STIRLING

Just after the point where the Teith swells the Forth's waters, the M9 motorway whooshes rudely over the enlarged river. Here, unnoticed by the hurrying drivers, is the weir that marks the Forth estuary's upper tidal limit. The weir once supplied power to a series of mills on the southern bank. That grim-looking building a little further round the riverbank is Cornton Vale, Scotland's main women's prison. The Forth now swings into the first of a series of large, looped meanders across the flat plain. On this sleepy, unassuming-looking stretch of river lies one of the most strategically important places in the whole country: Stirling.

For nearly 400 years this was the location of the furthest downstream bridge on the Forth. In ancient times it was also the lowest fording point. Impenetrable bog stood to the west. To the east lay 60 miles of broad river and firth, which could only be crossed by boat. Therefore any person, or army, wanting to travel to or from the Highlands by land would want to cross the Forth here. This made the crossing of utmost importance and made

Stirling Castle's position overlooking the river a vantage point worth fighting over. Stirling itself has been described as 'the brooch which clasps the Highlands and the Lowlands together'.

The City of Stirling

Stirling is the smallest of Scotland's seven cities (the other six are Edinburgh, Glasgow, Aberdeen, Dundee, Inverness and Perth), with a population of 36,000. It is also one of the newest, being awarded city status as part of Queen Elizabeth II's Golden Jubilee in 2002. This is a mere quirk of nomenclature, however, as Stirling has been one of the most important settlements throughout the entirety of Scotland's history. It was first settled in the Stone Age and the domineering crag has been a defensive fortification since the Roman occupation (although the Romans themselves preferred Doune). A chapel was dedicated here by King Alexander

The upper reach of the tide lies deep in the heart of the countryside.

I in 1110, and Stirling was created a Royal Burgh in 1130, cementing its importance as a trade and administrative centre. Stirling occasionally served as the capital of Scotland before Edinburgh officially took up that role in 1437.

The city remained a cluster of buildings on the rocky 'crag and tail' until it spilled out in grand Victorian avenues and, in the twentieth century, rather less appealing council estates, such as Raploch. The city's central shopping streets have suffered in recent years, but the 'Top of the Town' – the older, higher-up part of the city – is full of wonderful old buildings and lost corners to explore.

Not many churches in the United Kingdom have held a coronation – two in fact – and the Church of the Holy Rude is one of them. (The other is Westminster Abbey.) The coronation in question was that of King James VI, who was crowned King of Scots here on 29 July 1567. The church stands high on the crag near the castle and was first built in 1129. This structure burned down in 1405 and the current building was erected soon after, making it the second-oldest building in the city, after parts of the castle.

The seventeenth-century Argyll's Lodging is the grandest and most complete townhouse of its era in Scotland. Although 'townhouse' and 'lodging' don't really do the Renaissance-style building justice

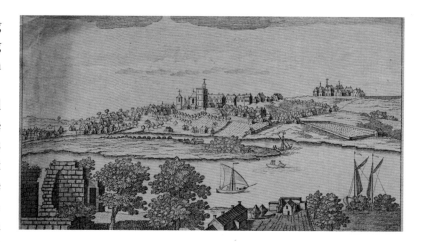

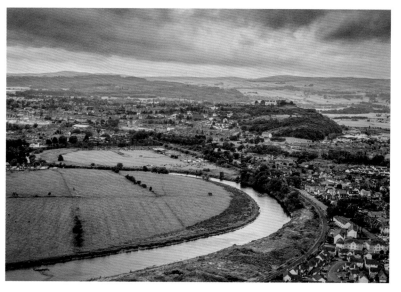

Above: Stirling in the eighteenth century.

Below: Stirling seen from the Wallace Monument; the Forth meanders in the foreground.

– it would be called a castle in its own right if it didn't happen to be right next door to the biggest one in the country.

Stirling Castle

Of Scotland's 2,000 remaining castles, Stirling is the biggest and one of the country's most historic. It guards what was for centuries the furthest downstream crossing of the river and was a vital nexus between highland and lowland, east and west. Several Scottish kings and queens were crowned here. Stirling Castle has endured at least sixteen sieges, the last being in 1746, when Bonnie Prince Charlie unsuccessfully tried to take the castle. It changed from Scottish to English hands frequently during the Scottish Wars of Independence (1296–1357). During the siege of 1304, Stirling Castle suffered the ignominy of a thumping from the largest trebuchet ever built. Edward I arrived in April with a large army and twelve powerful trebuchets, which he used to pound the castle walls, but the fortress held firm. Frustrated, Edward ordered a team of master carpenters to build the greatest war machine ever seen – a 56-foot-high stone-slinger called Warwolf. Construction took three months, and as Scots inside

Above: Church of the Holy Rude.

Below: The ancient stonework of Mar's Wark, near the castle.

the castle saw this monster nearing completion they surrendered. But Edward would have none of it – he wanted to see Warwolf in action. He refused the surrender and sent the Scots back inside. Warwolf was finished, a 350 lb missile was loaded into its sling and fired. The castle's gatehouse was totally flattened. History doesn't record how hard Edward was laughing and whooping, but it's fair to guess he was doing quite a bit of both.

The castle isn't a single structure, but a collection of buildings within a massive protective wall. These buildings have different purposes and were built at different times, although most of them date to the period 1490–1600, when the Stewart kings, James IV, James V and James VI, were consolidating Stirling as a royal power base. The architecture is cosmopolitan, with a mix of English, French and German styles, showcasing the Stewarts' international ambitions. At the heart of the castle are the Inner and Outer Closes, with a series of impressive buildings. The Royal Palace is an architectural gem, with exuberant stonework and an array of statues on its outer walls and beautiful woodcarvings within. It was the first Renaissance palace in Britain. James IV's Great Hall is the largest royal hall in Scotland. It has a fine hammer-beam roof and distinctive lime-washed outer walls. The King's Old Building dates to 1497 and has fine octagonal stair towers. The original

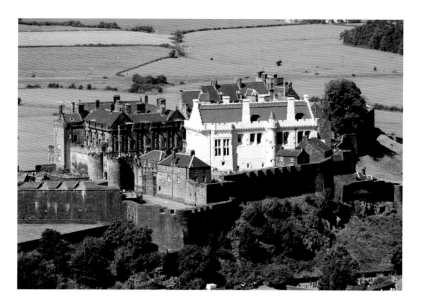

Above: The castle is really a cluster of buildings.

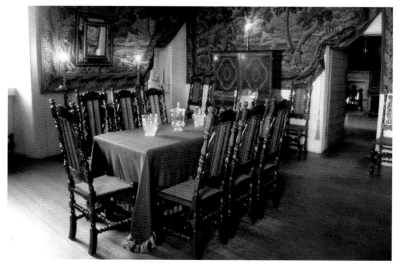

Below: The drawing room, Argyll's Lodging.

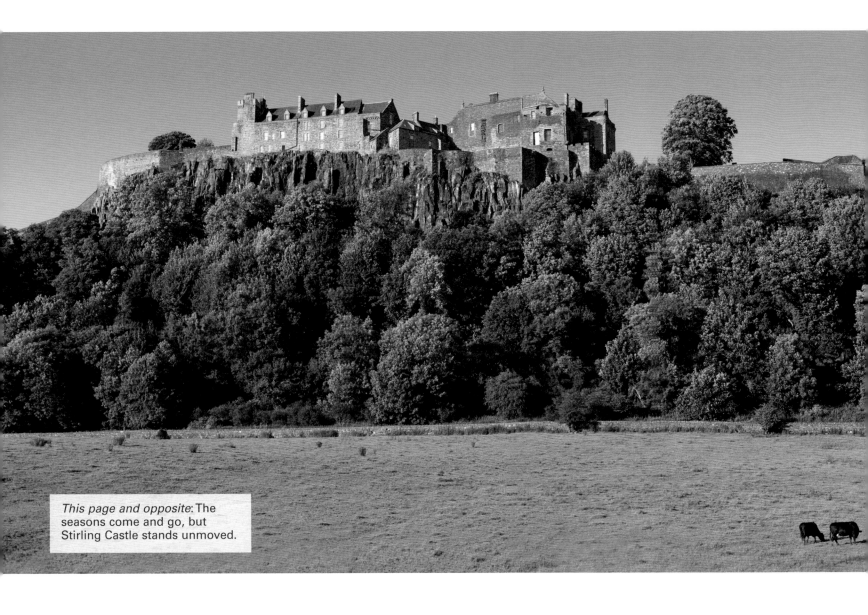

This page and opposite: The seasons come and go, but Stirling Castle stands unmoved.

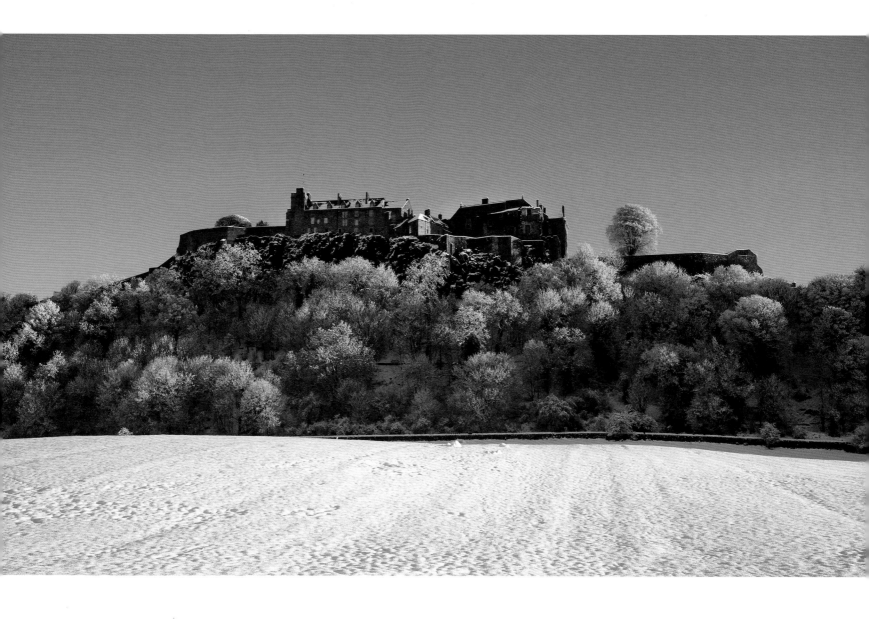

Chapel Royal was where Mary, Queen of Scots, was crowned on 9 September 1543. The chapel was remodelled on grander lines fifty years later. Mary's ghost – a pinkish apparition, apparently – is said to haunt the castle to this day. There are also extensive defences, cellars, storehouses, museums, kitchens, gardens and a working tapestry studio. The size of the castle and the variety of its structures make exploring it a full-day's adventure.

The castle must have been a lively place during the reign of James IV (1488–1513). He lived the life of a Renaissance king with gusto, ordering the construction of grand buildings and packing his palace with courtiers, international envoys and eccentrics. He employed a full-time alchemist, a man named Caldwell, who searched for *quinta essencia*, the mythical fifth element. It was here that an Italian charlatan called John Damian boldly claimed he could fly, in 1509. Damian strapped on a pair of homemade wings covered in feathers and announced that he would leap from the castle walls and fly to France. He leapt all right, but flew only downwards, landing on a midden and breaking his thigh.

The War Office owned Stirling Castle from 1800 to 1965 and they repurposed its finest buildings. The Great Hall was turned into barrack rooms, the beautiful Chapel Royal took on double duty as a dining hall and lecture room, the King's Old Building was an infirmary and the Royal Palace became the officers' mess. Thankfully, after the army moved out, a painstaking restoration programme has returned the buildings to their most majestic state.

The Most Important Bridge in Scotland

The old bridge that we can see today was built in the late 1400s. All goods brought over it into the Burgh were subject to a toll, which was collected by customs men who sat in a covered recess in the middle of the bridge. There were originally arched gates at either end, but these were probably removed by General Blackeney, Governor of Stirling Castle, who ordered the destruction of the south arch in 1745. Blackeney wanted to stop Bonnie Prince Charlie's forces from marching any further south at the start of the 1745 Jacobite Rising. At the same time all boats on the Forth were tied up at Stirling Bridge to prevent the rebels from crossing the river.

The sabotaged arch was rebuilt in 1749 and the bridge continued to be the main route into the lowlands from the north until 1833. It was made redundant by Stirling New Bridge, which was built just downstream in 1833. This was designed by Robert Stevenson, the eminent engineer who also built the Bell Rock Lighthouse and was the grandfather of author Robert Louis Stevenson.

By far the most celebrated of all the bridges built here was the wooden one that stood 65 yards upstream from the old bridge we see today. In 1297 it was the venue for one of the most famous events in Scottish history.

Opposite: The fifteenth-century stone bridge; the original was wooden.

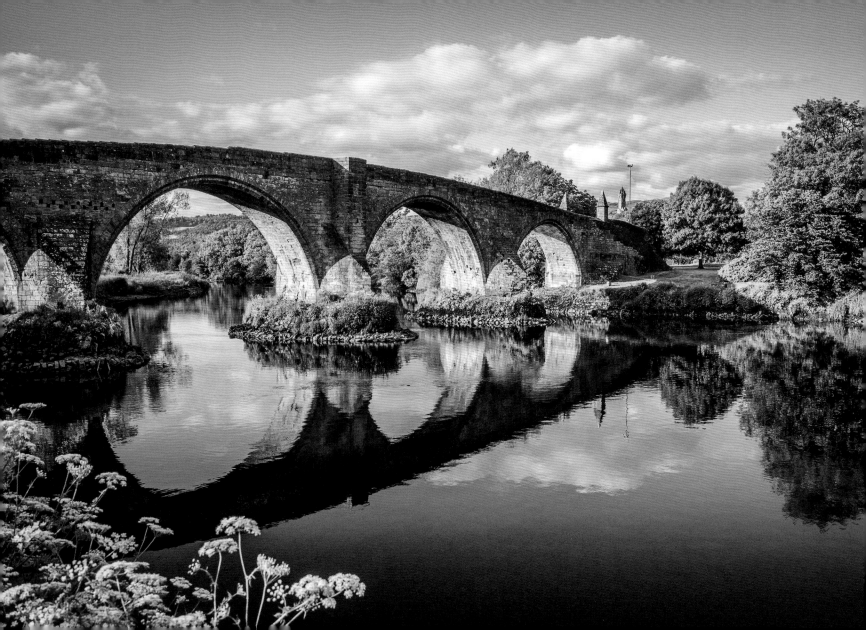

The Battle of Stirling Bridge

William Wallace was born into a family of minor nobles in 1272, in Elderslie, Renfrewshire. In 1297 the twenty-seven-year-old Wallace led an uprising against King Edward I of England, who then had Scotland under the heel of his powerful forces. Throughout the summer his uprising gained strength and, on 11 September, an army led by Wallace and fellow rebel Andrew Moray lined up at Stirling against a superior English force.

The Scottish army consisted of 6,000 infantry and 300 cavalry. Facing them were at least 8,000 English and Welsh infantry with 2,000 cavalry, led by John de Warenne, 6th Earl of Surrey, and Hugh de Cressingham, King Edward's treasurer in Scotland.

Warenne simply didn't want to be there. In 1296 Edward had made him 'warden of the kingdom and land of Scotland', but Warenne had come home to England after just a few months, complaining about the Scottish weather. He was ordered north again when Wallace's rebellion kicked off in spring 1297. At first he refused to go, but Edward would not be denied.

Hugh de Cressingham was a man loathed by the Scots for his habit of skinning Scottish war prisoners. (To be fair, his English compatriots didn't think much of him either.) Cressingham wanted a swift, thrifty war and he advised Warenne to make a rapid, direct attack on the Scots over Stirling Bridge. Warenne was pumped up from a victory over Scottish nobles at the recent Battle of Dunbar. The forces now facing him on the other side of the river seemed like a rabble in comparison to the knightly troop he had just routed. With his heart far from this battlefield, a quick assault seemed to Warenne like a good way to get things over with. He took Cressingham's advice.

Meanwhile, Wallace and Moray were in a terrific position high up on the Abbey Craig. With the battlefield and surrounding landscape laid out at 364 feet below them, planning their tactics must have been like playing a real-life game of 'Risk'.

The English bungling began early in the morning of the eleventh. Archers began to cross the bridge only to be swiftly called back when it was found out that Warenne had slept in. Rather than pounce on those few archers, the Scots waited. Eventually, the English knights and infantry began the slow crossing. The wooden bridge was narrow: only two or three horsemen could ride abreast across it. For the Scots, timing was now everything – attack too early and their infantry would be pushed back and then picked off by the fabled English archers. Wallace and Moray waited until 'as many of the enemy had come over as they believed they could overcome', around 5,400 English and Welsh infantry plus several hundred cavalry, and the order to attack was given.

Scots spearmen galloped down from the high ground by the Abbey Craig and smashed into the forces that made up the English bridgehead. The spearmen stabbed and slashed a path through the English vanguard to reach the end of the bridge itself. Here they

found more English knights in about as vulnerable a position as could be imagined – jammed together, high in the air above water, and presenting a broadside of horse and man to anyone who wanted to take a pop at them. Surrey's vanguard of heavy cavalry was now trapped north of the river. It was cut to ribbons. Even the archers on the south bank couldn't loose many arrows for fear of hitting their own knights. The few men who managed to throw off their armour jumped into the river and swam back across.

Hugh de Cressingham was one of the many who was killed. His body was flayed and the skin cut into pieces that were handed out as victory souvenirs. Wallace himself took 'a broad strip [of Cressingham's skin] ... taken from the head to the heel, to make therewith a baldrick for his sword'.

Although he had lost many knights and infantry, Warenne still had most of his army in a strong position on the south bank. He could have held the line of the Forth, as there was no way the Scots were going to try a bridge assault as the English had done. However, he had lost his nerve and he ordered the destruction of the bridge and a hasty retreat to Berwick. This left the garrison at Stirling Castle isolated and handed control of the Lowlands to the rebels. The Scots attacked the English supply train in The Pows, a wooded, marshy area, and dispatched many of the fleeing soldiers.

The battlefield itself was north of the old bridge, now covered by a housing estate and railway line. The actual timber bridge that the English forces so boldly crossed has also gone, being replaced by a stone structure. However, in the extremely dry summer of 1955, researchers found the stumps of two stone piers with part of an abutment on one bank in line with the piers.

The 1995 film *Braveheart* gets the result of the battle correct, but little else is accurate (the historical records do not note any Australians taking part). The tactics as shown in the movie are actually closer to those used by the Scots in the Battle of Bannockburn.

Nevertheless, it's an exciting tale and the battle was definitely a resounding victory for the Scots. Wallace was knighted after the battle, becoming Sir William Wallace and 'Guardian of the Kingdom of Scotland and leader of its armies'. However, he only held this title for a year. In 1298 Wallace's army was defeated at Falkirk, just a few miles along the Forth Valley, and he passed the guardianship on to the future king, Robert the Bruce. Wallace's record in major battles was therefore: Won – 1, Lost – 1.

After Falkirk, Wallace evaded capture by the English until 1305. John de Menteith, a Scottish knight loyal to Edward, finally turned him over to English soldiers at Robroyston near Glasgow. Wallace was taken to London, tried and found guilty of treason. His execution was designed to be as brutal as possible, to send a clear message to would-be Scottish rebels. Wallace was stripped naked and dragged through the streets of London behind a horse. At Smithfield he was hanged, but cut down while he was still alive, then emasculated, eviscerated and had his bowels burnt before

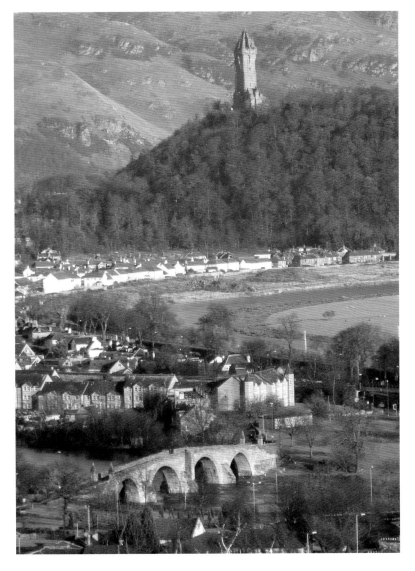

him. He was finally beheaded and chopped into four parts. His tarred head was stuck on a pike on London Bridge and the other pieces of his body were sent around the country for similar display.

The Battle of Stirling Bridge had not been decisive. England regained the upper hand at Falkirk the next year. By 1304 Scotland was fully in English control. Then in 1306 Robert the Bruce seized the Scottish throne and open war was unleashed again.

Edward II inherited the English throne in 1307, but he was a wimp of a man compared to his father. Nevertheless, his forces still held Stirling Castle, the lynchpin to the Highlands. Then, in 1314, it was besieged by Edward Bruce, Robert's younger brother. The encircled English garrison agreed that if they weren't relieved by compatriots from the south by mid-summer then they would surrender the castle to Bruce.

This was a challenge that Edward had to respond to. He gathered 2,000 cavalry and 15,000 infantry and sent them north. The Scottish forces were then only around 7,000 men, with fewer than 500 cavalry. The Scots were outnumbered at least two to one, if not by more. So it was that on 23 June 1314 the two sides clashed, with a fabled single combat commencing proceedings.

The battlefield was amid those houses, beyond the bridge.

The Battle of Bannockburn

Nicola Sturgeon, wearing full armour, mounts her proud white palfrey. She urges her steed out from the lines of her Scottish soldiers to get a closer look at the overwhelming English forces arrayed across the muddy turf.

'Shall I signal the attack, Your Grace?' asks her trusted steward.

'Nay,' replies The Sturgeon. 'First, me and him.' She rises in her saddle, levelling her battleaxe at the English lines. 'Osborne!' she yells. 'You snivelling bag of ill-worn privilege! Are you too much of a worm to face me in single combat?'

Her words prick the English aristocrat's pride. George de Osborne knows that his ambitious king, Cameron, would laugh at his cowardice if he refused. Besides, de Osborne is a man of breeding and experience. He could easily unseat this impudent northern upstart.

'I wonder, men, if she has had her haggis this morning?' laughs de Osborne to his ranks. 'Well, we shall find out when I split her gizzard! Ha!'

And to great cheers he sinks his spurs into the flanks of his colossal, snorting stallion and gallops across the carse.

A roar even more violent rises from the Scots as The Sturgeon hefts her gleaming battleaxe in her gauntlet-clad hand and urges her palfrey a few paces forwards.

De Osborne's pace is fearful. The yards disappear beneath the blurred hooves. The shouting fades as every eye on the field watches for the smash. De Osborne lowers his lance and aims it ... He grins as he sees that The Sturgeon stands still, not daring to charge ... She is afraid ... no ... she is standing her ground... As de Osborne's lance spears for her body she manoeuvres her mount nimbly to the side, making room for an arcing axe-blow that cuts the very atoms of the air and arrives at the perfect time and with godly power to cleave de Osborne's head utterly in twain, splitting his helm like paper and dividing his body down to his heart. De Osborne's brains and blood splatter into the mud and he topples from his horse.

'NOW we attack!' bellows The Sturgeon.

That might sound like something from a teenager's attempt at a historical fantasy novel, but it's pretty much how the decisive battle for Scotland's independence actually started in 1314. Robert the Bruce and Henry de Bohun faced each other in single combat before the battle started. The stakes couldn't be higher. Bruce was 'The Man Who Would Be King' – the wildly popular totem of Scottish independence. De Bohun was a famous knight of court whose grandfather had been Edward I's godfather. If de Bohun triumphed it would have been a terrible blow for Scottish hopes. However, despite the great risk that the King of Scots had taken, the only thing Bruce regretted was that he had shattered the shaft of his favourite axe. The courage of their king must have fired his troops with a supercharging dose of adrenaline and patriotism. The English didn't know what had hit them.

Nevertheless, it wasn't a walkover. Bannockburn was almost

unique among medieval battles in that it lasted for two days – most battles then only lasted a few hours.

The Scots used their knowledge of the terrain well: they kept the refuge of a forest at their backs, dug hidden pits to hinder the English cavalry and ensured the boggy waters of the Bannockburn hemmed in the English on the eastern flank.

Bruce's forces had the better of the first day, but they were far from certain of victory. A full-scale, set-piece battle, with the English archers in prime position, could still be disastrous. In the evening, Bruce may have considered leaving to try again another day. At this critical point Sir Alexander Seton, a Scottish noble who had been fighting for England, defected. He brought with him invaluable intelligence: Edward's army was in a confined position and its morale was low. Bruce decided to risk everything on a full assault in the early morning.

The Scots crept out of the wood in the dawn mist and formed up ready to set about their enemy. A priest came to the front of the ranks to bless them. Edward is reported to have said in surprise, 'They pray for mercy!'

An attendant replied, 'They ask for mercy, but not from you. They ask God for mercy for their sins. I'll tell you something for a fact, that yon men will win all or die. None will flee for fear of death.'

The Scots made devastating use of their schiltrons. These were great circles of up to 2,000 men carrying fearsome 12-foot-long spears and packed together in a well-drilled formation.

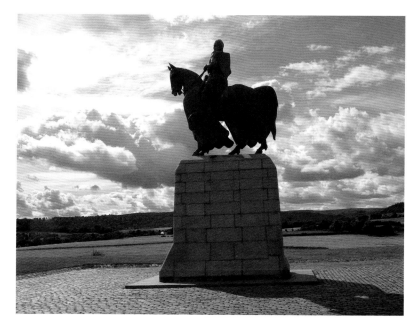

Statue of Robert the Bruce at Bannockburn.

The English cavalry could find no way through the sea of bristling points despite their hooves and armour. Schiltrons had previously been used mostly in defence. So when Bruce used them at Bannockburn in a coordinated attack, the English cavalry was thrown into confusion, as a fox would be to find several determined hedgehogs balled-up and rolling at it with vengeful intent.

The English knights were trapped between the schiltrons and their own army. The English and Welsh longbowmen were shooed away from the flanks by the Scottish 500-horse light cavalry and could offer no cover. The centre of the field was a sea of ferocious hand-to-hand combat between knights and spearmen. Carnage ensued.

When it was clear that the English had lost, Edward II fled for safety in Dunbar. Much of his army was massacred as it tried to escape to the safety of the English border, ninety miles to the south. Out of 16,000 English infantrymen, around 11,000 were killed. About 700 English men-at-arms were killed and 500 more were taken for ransom. Scottish losses were comparatively light, with only two knights among those killed. The overwhelming victory gave Scotland de facto independence and was a landmark in Scottish history.

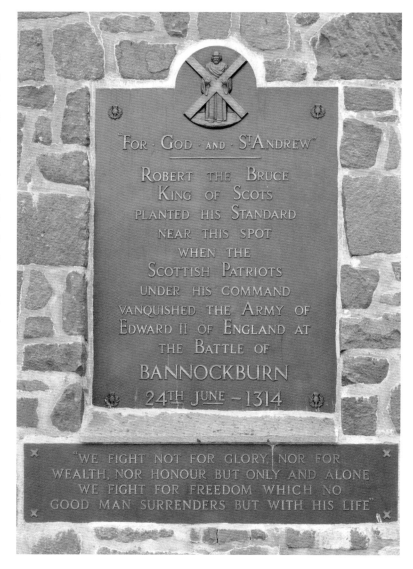

Plaque at the battleground.

Wallace Monument

There was an exuberant revival of Scottish identity in the early nineteenth century, pioneered by national cultural hero Sir Walter Scott. The country found its pride again after a century of being little more than 'North Britain'. The 'romantic rebel' character of William Wallace seemed a perfect focus for this rediscovery of the national self, and over twenty monuments were built to him throughout the country. There was a particular call for a superlative national monument to Wallace, and a design competition was announced. Funding was provided by donations from patriots at home and abroad – the Italian national leader Giuseppe Garibaldi made a particularly large gift.

One early idea called for a giant statue of Wallace himself on the scale of the Statue of Liberty. Ultimately the winning design, by the architect J. T. Rochead, was for a traditional Scottish tower-house castle, extended to a great height and topped with a stone crown spire, much like the ones adorning St Giles Cathedral in Edinburgh and King's College in Aberdeen.

The great cities of Edinburgh and Glasgow had both wanted to host the monument, but Stirling offered a neutral choice and was more historically relevant to Wallace. The Abbey Craig is a wooded lump of old volcano with a commanding view of the

Left: Thomas Telford's circular-arch road bridge over the Bannock Burn, just downstream from the battleground.

Opposite: The Wallace Monument.

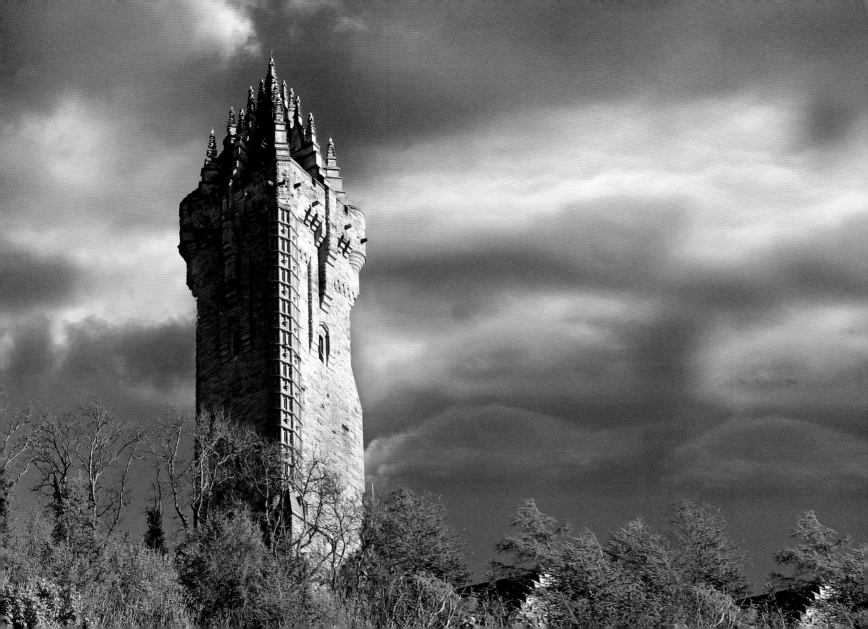

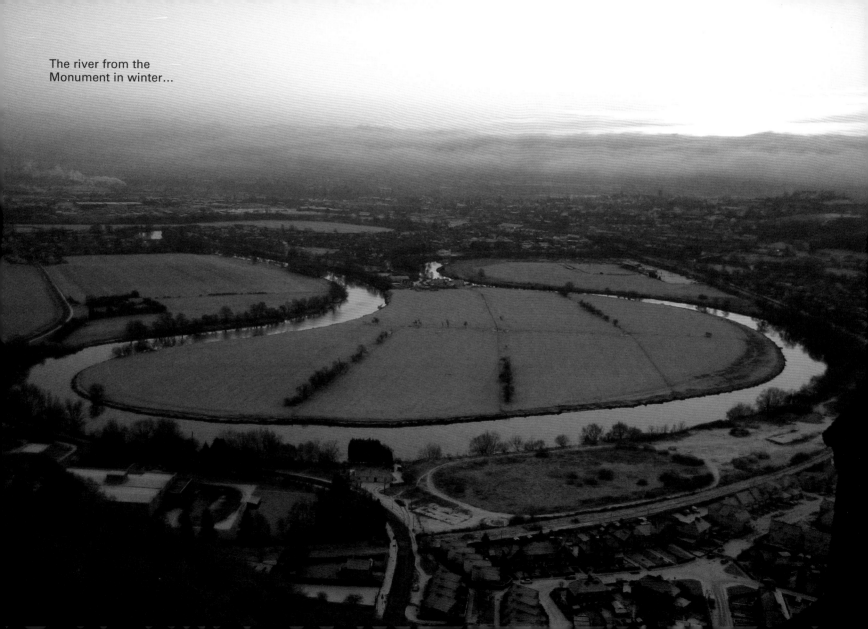

The river from the
Monument in winter...

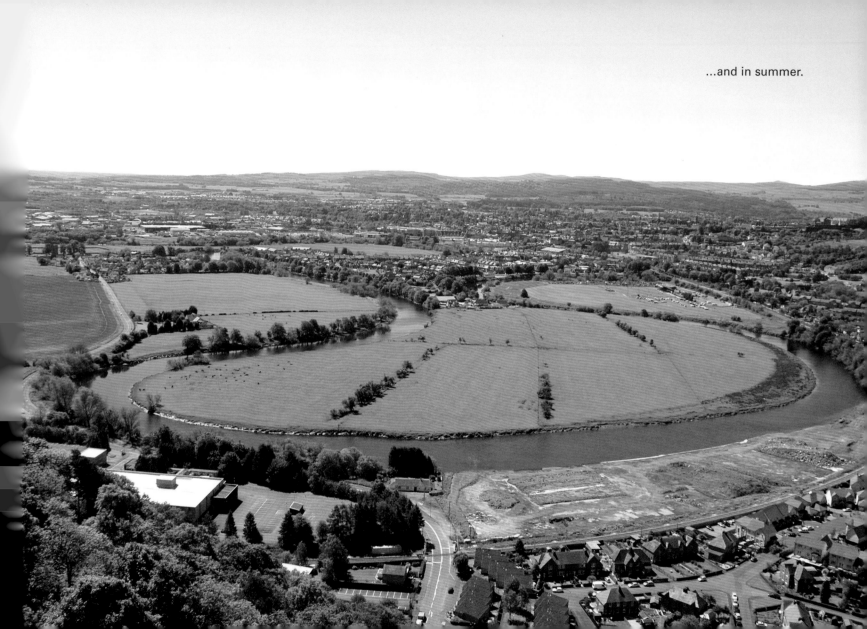

...and in summer.

river, much like its near neighbour, Castle Hill. The Craig's vantage point was supposedly used by William Wallace to observe the gathering army of King Edward I of England, just before the Battle of Stirling Bridge. Abbey Craig was not only prominent, but it also had an abundance of stone that could be used to actually build the structure. The National Wallace Monument was finally completed in 1869 after eight years' construction. It stands 220 feet high, with the Abbey Craig boosting it a further 300 feet, putting the top of the monument 520 feet above the looping river below.

The monument has four levels above the ground floor, each with a vast, high-ceilinged room. Level 1 is the Hall of Arms, featuring weapons and the story of William Wallace and the Battle of Stirling Bridge. Level 2 is known as the Hall of Heroes and here you can see marble statues of famous Scotsmen. Here, too, are several artefacts thought to have been owned by Wallace himself. These include the 700-year-old Wallace Sword, a whopping 5 feet 4 inches long and weighing almost 6.5 lb. A man who could have wielded such a colossal weapon would have been a fearsome foe indeed. Level 3 is the Royal Chamber, where several illuminated panels explain the background to the monument itself. The final set of narrow steps leads to Level 4, the open viewing platform beneath the remarkable masonry of the crown. It is not for those wary of heights!

The curling external stair of 246 steps is a thrilling climb and the view from the crown at the top of the monument will not disappoint. The river's geography is laid out plainly before your

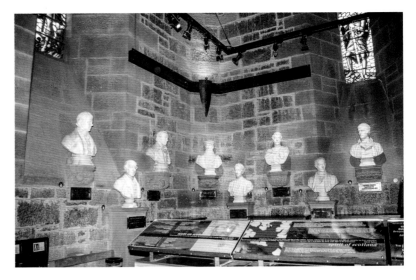
Inside the Hall of Heroes.

eyes: its source on Ben Lomond, the curves and quirks by Stirling that were so important in times past, right on through to the Forth Bridges and the widening tidal shores in the east.

Cambuskenneth Abbey

Cambuskenneth village has to be one of the least known of Scotland's important historic sites. It is literally overlooked by two

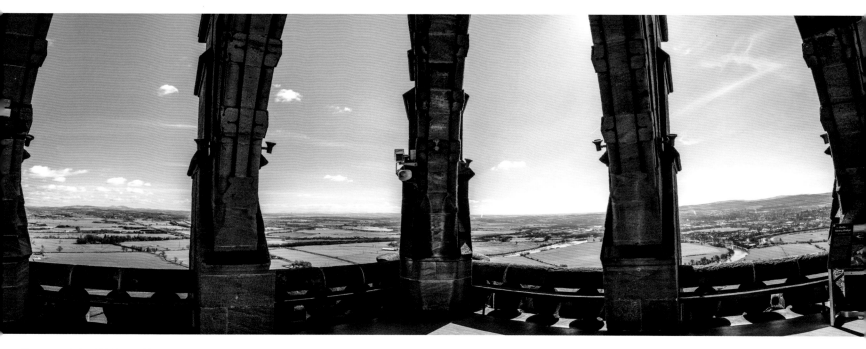

Crown of the Wallace Monument and the river beyond.

far more famous sites – the Wallace Monument and Stirling Castle – but Cambuskenneth is a peaceful little place to visit, with an interesting story to tell. An abbey was founded here in 1140 by David I, on a spit of land between two wide river meanders, just a mile's walk and a few pulls of the ferryman's oars from Stirling Castle. 'Cambus' is the Anglicised form of the Scottish Gaelic 'camas', meaning an inlet or harbour. The 'Kenneth' is probably to commemorate Kenneth MacAlpin, King of the Picts and, according to legend, the first King of Scots.

The abbey's royal pedigree and its closeness to such a nationally important stronghold helped it become a rich and influential institution. King Edward I of England (while on his military campaigns

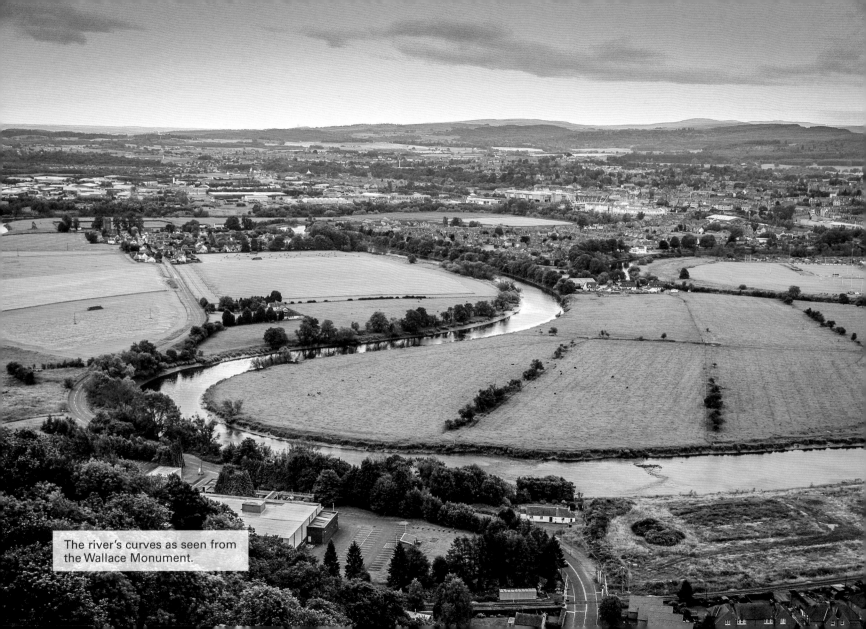

The river's curves as seen from the Wallace Monument.

in Scotland) and Robert the Bruce are among the monarchs who prayed regularly at the abbey. Bruce also held his parliament there in 1326 to confirm the succession of his son David II.

Like many rich ecclesiastical buildings in Scotland, the abbey was looted and burned during the Reformation in the sixteenth century. The only building left today is the thirteenth-century bell tower – the only free-standing belfry in Scotland. There are also the knee-high stubs of the abbey's nave, cloister, garth, refectory, chapter house and church. The abbey's west door now leads to a peaceful cemetery.

The foolishly gung-ho King James III (1451–88) has found his rest in a quiet nook here. More interested in empire-building than kingship, James suggested that Scotland should invade, among other places, Guelders (a province in the Low Countries), Saintonge (a province in west France) and Brittany. These deluded ambitions made him unpopular with Parliament, several factions of nobles and much of the ordinary population. This discontent came to a head in a field at Sauchieburn, just a couple of miles south of Stirling, in 1488, when James met his foes in battle. The king fell from his horse and either died in the tumble or was promptly finished off by enemy soldiers. The large stone that today marks his grave was paid for by Queen Victoria.

James did make one very valuable contribution to the Scottish nation, through his marriage to Margaret of Denmark in July 1469.

The bell tower is all of Cambuskenneth Abbey that stands above knee height.

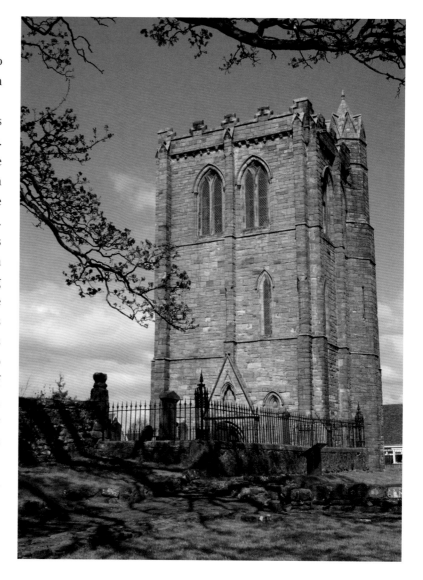

The bride's father, Christian I of Denmark, Norway and Sweden, found himself strapped for royal cash, so he gave the Orkney and Shetland Islands in lieu of a dowry. The Norwegian crown never did find the funds to redeem this particular pawnbroker's ticket, and the archipelagos have been part of Scotland ever since.

Despite its proximity to the city centre, Cambuskenneth is cut off by a snaking meander of the river. The only direct connection to Stirling is by a footbridge, which in 1935 replaced the ferry service that had existed for at least 600 years. The long drive round to get to the village from Stirling has helped it remain a rural oasis. As you tootle down the dead-end road that leads to the abbey and nearby village, you'll see cows lying in riverside meadows with the castle in the background – a view that has been unchanged for centuries.

The village was widely famous for its market gardens and apple orchards. In the 1920s the Glasgow Boys' school of impressionist painters discovered its fecund charms. Edward Arthur Walton had a studio in Cambuskenneth and many of his fellows also painted local rural scenes.

South of the river at Cambuskenneth are some leisure and retail parks and Forthbank Stadium, the home of Stirling Albion Football Club since 1993.

Above: Close to the city, but still full of cows.

Below: The old ferry at Cambuskenneth, replaced by a footbridge in 1935.

The Old Harbour

The only vessels you're likely to see on the river at Stirling these days are the boats belonging to the thriving Stirling Rowing Club, or the occasional kayaker who is paddling the river. However, Stirling once had a bustling harbour. In 1525 it was listed with Edinburgh, Aberdeen, Dundee, Perth and St Andrews as one of Scotland's largest ports. As ships grew in size, the river's many tight bends and its shifting shallows prevented newer vessels from making it upstream. A few smaller ships were still visiting the harbour at the outbreak of the Second World War, many of them bringing tea to the thirsting nation. Trade in agricultural materials continued for a while after the war, before the trade became uneconomic. The old wharves are now long gone; a small park stands in their stead, overlooking a great loop in the river. This lies 1,312 feet north-east of the railway station and can easily be visited if you are walking over the footbridge to Cambuskenneth.

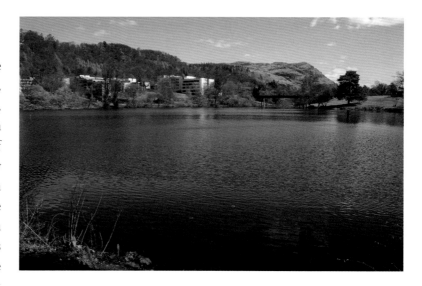

Stirling University.

Stirling University

Scotland had four universities before England had three – St Andrews, Glasgow, Aberdeen and Edinburgh were all established by 1582. With such an abundance of learning institutions there was a bit of a gap – 385 years, in fact – before the next new one was built at Stirling in 1967. It was worth the wait: Stirling University has one of the most beautiful campuses in the world. It is built on the wooded estate of the Robert Adam-designed Airthrey Castle, which nestles in a nook between the Abbey Craig and the crumpled Ochil Hills. The campus has its own twisting loch and serene grounds that surely inspire the most elevated of thoughts in its student inhabitants.

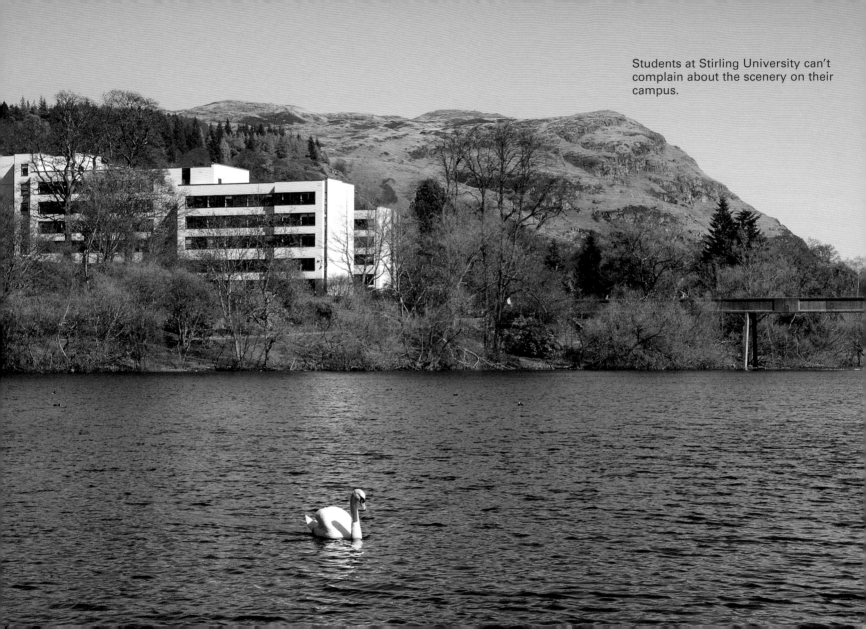

Students at Stirling University can't complain about the scenery on their campus.

How many rivers do you see? After Stirling comes meander after meander.

THE INNER FIRTH

After Stirling, the River Forth becomes the Firth of Forth – a tidal estuary. It continues in this form for a further 55 miles, reaching a maximum width of 19 miles at its mouth. The Firth of Forth is the most substantial estuary on the east coast of Scotland and it features many points of historical and contemporary interest.

River Carron

Two miles on from Kincardine, the River Carron joins the Forth. This rather muddy tributary isn't the most spectacular of rivers, but what it lacks in looks it more than makes up for in character.

The largest ironworks in Europe – the Carron Company – once stood on its northern bank. This was founded in 1759, 2 miles north of Falkirk, and it became one of the most celebrated manufacturers in the Industrial Revolution. Perhaps its most famous product was the naval cannon known as the carronade. These weapons were very powerful, but short, light and easy to use, and were very popular from the 1770s to the 1850s. Carronades helped the Royal Navy outgun the French during the Napoleonic Wars and their broadsides shredded ships and sailors at the Battle of Trafalgar.

The River Carron is also where we encounter the Forth and Clyde canal, a remarkable waterway that has more than its fair share of charms. The canal's entry into the firth is now marked by one of Britain's boldest public artworks.

The Kelpies

'Already seen them from the motorway.' This is true. You cannot miss the world's largest equine sculptures as you drive along the M9: they rear 98 feet over the carriageway and seem ready to snap down and gobble up any passing car that looks too much like a carrot.

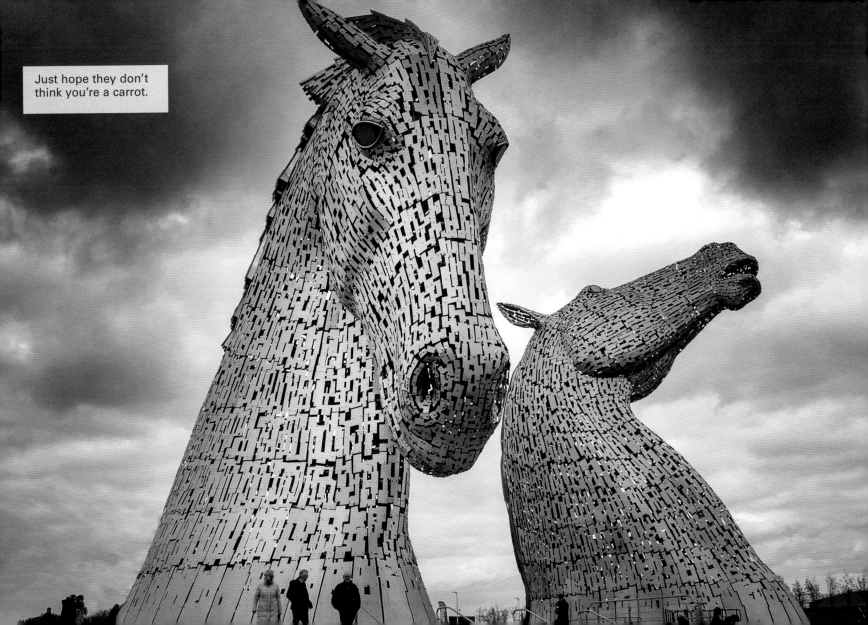

Just hope they don't think you're a carrot.

However, to really enjoy them you have to get close enough to touch these sensational sculptures. Up close their size is humbling and you can appreciate their extraordinary construction. Sculptor Andy Scott has used 600 tonnes of steel plates to create the flowing, rippling heads of two muscular horses. Textured skin rendered in steel. You can almost see the veins pulsing beneath the skin.

The eastern kelpie glares down at you over flaring nostrils. The western one is throwing his head to the sky in a shriek of excitement or anger. From the tight angle of their ears it seems to me that these spirits are a little bit annoyed at being summoned from their element and embodied in ours. Best not to visit at a misty midnight – who knows what magic could be invoked. One quick chomp and they'd drag you down to their watery home.

A kelpie is a water spirit that can transform from human to horse and is renowned for its strength. This transforming power is a very apt theme: the surrounding area was at the heart of the Scottish Industrial Revolution. The dozens of local mines, factories, refineries, foundries and brickworks helped change the way we live forever, and it was horsepower that pulled their wagons, ploughs, barges and coalships.

The heads were specifically modelled on Clydesdale horses, the powerhouses of the early industry. In the 1930s, the biggest working horse in the world plied his trade in nearby Falkirk. *Carnera* stood over 19 hands high and he spent his working life pulling 3-tonne wagons for Barrs, the makers of Irn Bru – Scotland's other national drink.

The Kelpies are the centrepiece of a remarkable regeneration project, The Helix, that has turned 860 acres of uninviting brownfield land by a motorway into a landscaped park with a boating loch, meadow, adventure playground and wetland. The ducks are delighted. It's the final chapter in a bona fide success story: the restoration of the Forth and Clyde Canal.

Forth and Clyde Canal

The waters around the far north of Scotland are among the most boisterous in Britain, with frequent storms, Arctic chills and some of the fastest tides in the world. This can make travelling from the North Sea to the Irish Sea a daunting prospect.

The Forth and Clyde Canal aimed to bypass all that danger by giving seagoing vessels a safe route across Scotland's narrow 'waist', joining the Firth of Forth and the Firth of Clyde. This would also open up new markets in Europe and America. The canal's eastern entry was at Grangemouth Docks and it reached the west coast 35 miles later at Bowling. It was Scotland's first canal, and it opened in 1790.

There was a busy basin at Port Dundas in Glasgow and from 1822 a set of locks near Falkirk joined it to the Union Canal, which ran east to Edinburgh. Scotland's two greatest cities and its two main coasts were now connected by navigable waterways. The

Forth and Clyde Canal was the venue for a technological advance of global importance: the maiden voyage of the first practical steamboat. The Lanarkshire engineer grasped the potential of a Watt steam engine applied to transport and spent years building various prototype steamboats. His first complete success was the *Charlotte Dundas*, built nearby at Grangemouth, which first sailed on the canal on 4 January 1803. A refined version was soon towing a pair of 70-tonne barges at a heady average speed of about 2 mph. Steamboats were here to stay.

However, ships began to outgrow the canal, and the railways took away most of the rest of its traffic. It fell into severe decline from the 1930s and was closed for good in 1963 when the A80 dual carriageway was built through, rather than over, it. By the 1990s it was Scotland's longest puddle – a trolley-filled, weed-clogged, 35-mile mess.

When National Lottery funds were set aside for grand projects to help celebrate the millennium in 2000, the canal cashed in. In a wonderfully bold plan, the Forth and Clyde Canal was cleaned up and its obstructions cleared (including a £2 million new bridge to lift that A80 up a bit). A new canal connection to the River Carron, and hence the River Forth, was built. Also included in the scheme was a link to the similarly spruced up Union Canal, to replace the eleven locks at Falkirk that were filled in during the 1930s. The £83.5 million Millennium Link project was the largest canal restoration ever seen in Britain.

This link was made possible with a new boat-lifting device that is a true one of a kind and has become a Scottish landmark that is now the second most visited attraction in Scotland, after Edinburgh Castle: the Falkirk Wheel.

The Falkirk Wheel

On 27 May 2002 boats could once more travel from Forth to Clyde, to Glasgow and Edinburgh, thanks to the world's only rotating boat lift. The 100-foot-tall Falkirk Wheel is an engineering masterpiece and a deservedly popular visitor attraction.

The Union Canal was extended past the site of the old locks and through a new tunnel drilled underneath the Antonine Wall. Boats exit the tunnel onto a hooped aqueduct that ends abruptly in mid-air, 79 feet above the basin of the Forth and Clyde Canal.

To bridge this gap, boats sail into water-filled caissons – basically enormous bathtubs – which are held at the ends of a rotating arm 115 feet long. These caissons hold 500-tonnes worth of water and boats. Thanks to Archimedes' Principle, each vessel displaces its own weight in water, so the arm is always perfectly in balance even if there are four boats in one caisson and none in the other.

The caissons are sealed and the arm rotates. The caissons are held within the arms by wheels running on rails. As the arm turns, gears ensure that the caissons turn the opposite way at

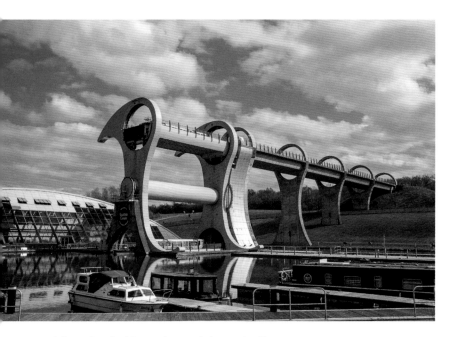

A boat loaded in each gondola, and off we go ...

New Canal Extension

When the Forth and Clyde Canal fell into disuse its original route into the Forth was obliterated by a new motorway, houses and factories. The construction of an exit into the River Carron as part of the Millennium Link made the canal accessible from the firth once again, but the connection was far from ideal. Between the last lock and the sea, two roads and two pipes crossed the river at a low level, severely limiting headroom for boats at high tide.

Happily, as part of the Helix project, a new 2,850-foot section of canal has been built to bypass this. The canal now runs cleanly underneath the four fixed bridges to a new sea lock and so out to the Forth.

The Antonine Wall

The frontiers of the Roman Empire once stretched for 3,106 miles across three continents. The furthest northern edge of their realm was marked by a man-made barrier linking the natural defences of the Forth and Clyde rivers – the Antonine Wall. This was the end of the known world. Beyond here it was all dragons ...

Emperor Hadrian pushed back the tide of natives as far as the Solway-Tyne isthmus and put up his famous stone wall there in AD 122. He was succeeded sixteen years later by Antoninus Pius

the same rate, keeping them perfectly level. It takes surprisingly little energy to move the wheel – the same as boiling eight kettles. The wheel's ingenious gearing system was first demonstrated to potential funders by engineer Tony Kettle using his daughter's Lego. Passing through the Falkirk locks used to take a boat most of a day; a spin in the wheel lasts only fifteen minutes.

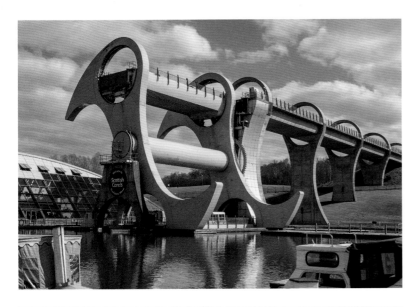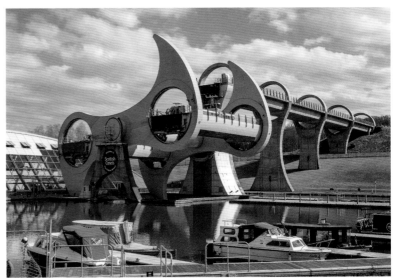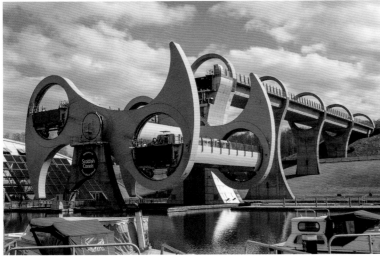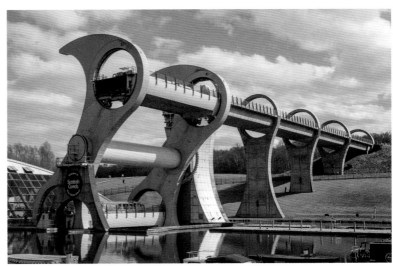

The remains of the Antonine Wall near Roughcastle.

who flung the empire further north to the Clyde-Forth watershed. In AD 142 he ordered the construction of a turf wall 9 feet high with a 16-feet-deep ditch and a large outer mound along this 39-mile line. It took twelve years to build. The wall was manned by 7,000 soldiers in seventeen forts and many other fortlets and camps, from countries as exotic as Syria, Spain and Algeria. They must have been delighted to get that posting. However, it was only in use for eight years – soon after Antoninus Pius died in AD 161, his wall was abandoned and troops reoccupied Hadrian's Wall.

The remains on show today aren't as spectacular as those of Hadrian's Wall. With the departed soldiers gone, most of the forts were raided for building materials and the wall's historic past was soon forgotten. The fevered industrialisation of Scotland's central belt saw most of the remaining turf and ditch structures obliterated by canals, railways, houses and factories. However, a section has been saved and since 2008 has been inscribed as a World Heritage Site. The best surviving stretch of ditch is at Watling Lodge, Falkirk, and you can see the earthworks of the fort and rampart ditch at Rough Castle, Bonnybridge.

Grangemouth

It wouldn't be surprising if Rick Deckard descended from the clouds in a police spinner and started hunting replicants among the neon-lit towers and chimneys of pulsing flame – welcome to Grangemouth, one of Britain's mightiest oil refineries. By day the site is merely a sprawling labyrinth of tanks, pipes and metal gantries. At night, however, it lights up like a Blade Runner cityscape, taking on its own peculiar industrial beauty.

The refinery opened in 1924, in a location where tanker ships could have easy access and where there were plenty of skilled workers on hand. The world's first oil works had opened in 1851 just 8 miles away, near Bathgate, producing oil from shale using the process patented by Glasgow scientist Dr James 'Paraffin' Young. There were thousands of oil workers in the Forth Valley, and the refinery was soon processing 360,000 tonnes of crude oil per year. Today it can handle 210,000 barrels every twenty-four hours. Young has become known as the 'Father of the Petrochemical Industry'.

Alloa

At one time you could get a heady buzz just from walking the streets of Alloa. There were nine huge breweries in the town and the largest grain distillery in Scotland. In 1762 George Younger was the first to brew ales here and he was soon shipping them throughout the UK and to the furthest corners of the British Empire. A whole generation of teenage lager drinkers can thank the Alloa Brewery Company for 'Graham's Golden Lager', which

Water, sandbanks and a few tired old boats having a rest.

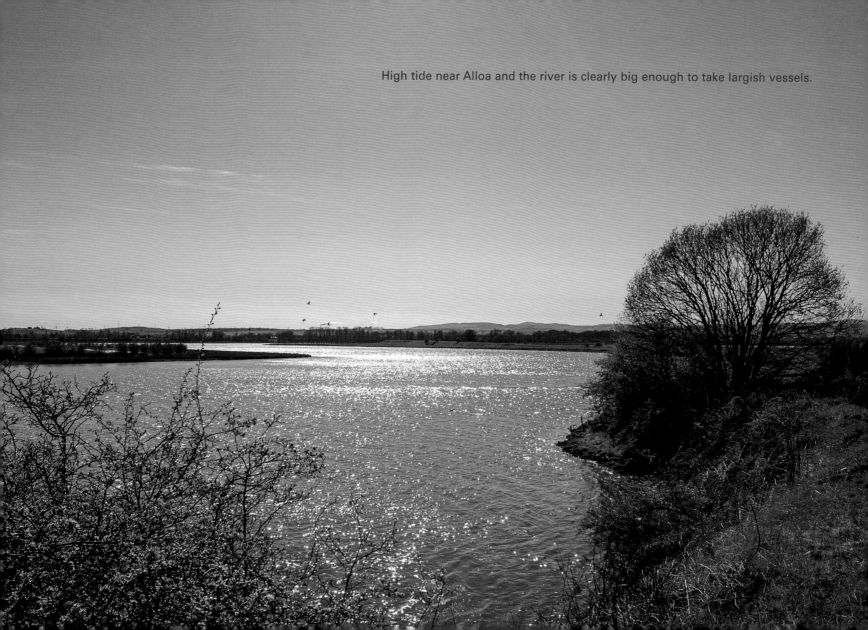

High tide near Alloa and the river is clearly big enough to take largish vessels.

was renamed 'Skol' in the 1950s. Today only the Williams Brothers still brew beer in Alloa, but happily their brews are delicious and their company is flourishing.

Alloa was a busy port from the eighteenth century onwards, and many Glasgow-made goods destined for Europe were shipped from here. However, by the 1960s the small harbour was eclipsed by modern ports like Grangemouth, which could handle larger vessels. Alloa's port closed in 1970.

Now it's tricky to get down to the river itself at Alloa – most of the north shore is occupied by the enormous United Glassworks site. Glass production has a long history here, and amid the modern glass factory structures is the Northern Glass Cone. This 79-foot-high brick structure was where glass was made in the nineteenth century, with men working at furious furnaces inside, moulding and stacking the glass. It must have been like working in a living circle of hell. There were once several glass cones here, but only one stands today and there are only three others in the whole of Britain.

To see the river at this point you are better to head over to the opposite bank and visit South Alloa. You could once have done this by ferry or the railway line to Throsk, but now you'll have to go via the Clackmannanshire Bridge. South Alloa itself is a sleepy line of houses running out to a bend of the river. There's a grassy embankment where you can walk and find a serene spot to sit amid the coconut-scented whin bushes, which happily overpower the honk from the glassworks. The piece of land across the water

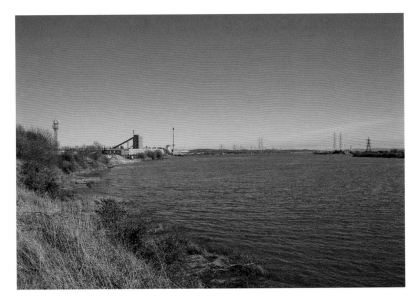

An industrial stretch of shore – Alloa glassworks on the shore to the left.

to the west here is an island called the Inch. There was once a productive farm on the Inch, but its defences were breached by the river in 1982 and it is frequently inundated by salty water. Great for wading birds, not so good for barley. The locals tell the story of how the family had to abandon their farm in a frantic hurry one winter night, as an approaching storm and high tide threatened imminent inundation. Apparently the table in the kitchen of the surviving farmhouse is still set for a dinner that was never eaten.

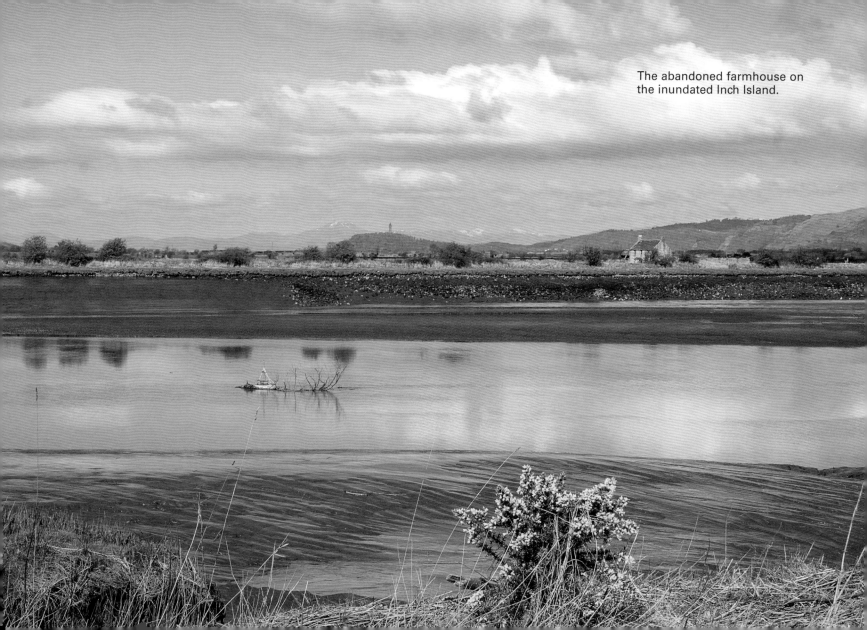

The abandoned farmhouse on the inundated Inch Island.

The village of Dunmore is a snoozy and very pretty square of houses set around a pristine bowling green with an old water pump. The village was built in the 1820s as a model village for the workers on the nearby Dunmore estate. The last cottage on the south side of the village was the smithy – you'll see its front door is shaped as a horseshoe. Just to the south is one of the most extraordinary buildings in Scotland: the Dunmore Pineapple. This was built in the late eighteenth century, a time when the rarity and exotic sweetness of this Caribbean fruit made them popular symbols of wealth and hospitality. The Pineapple forms part of a walled garden that once supplied food for the Earls of Dunmore, who lived in the now-derelict Dunmore House. The building contained a hothouse where, appropriately enough, pineapples were grown. It is a superlative piece of stonemasonry, carefully designed to shed every drop of water to prevent ice from cracking its elaborate structure. It was probably the work of the Scottish architect Sir William Chambers, who designed the pagoda in London's Kew Gardens and Somerset House. The Pineapple is now owned by the National Trust, who run it as a holiday let. The grounds are open to the public and there are lovely woodland walks.

Alloa's most famous historical landmark is the fifteenth-century Alloa Tower. This is part of what was once a larger medieval

Above: Estate workers' houses at Dunmore.

Below: The Forth slides by the bowling green at Dunmore.

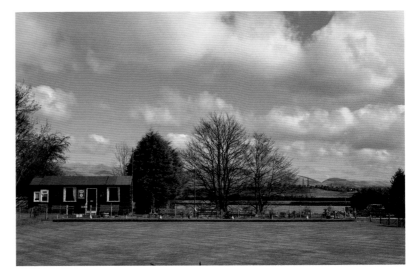

residence, built by the Erskine family, the Earls of Mar. It's a grand and impressive building, one of the largest and earliest of Scotland's tower houses. It has been spruced up over the centuries, but still has its original medieval wooden roof and battlements. It's very close neighbour is an enormous supermarket, which reduces the historical charm of the site somewhat, although it does give you a handy place to grab the ingredients for a picnic. Far more spectacular in its setting is Clackmannan Tower, just 1.25 miles to the east.

For the most complete view of the River Forth's course, short of hiring a hot-air balloon, you can't beat a walk to Clackmannan Tower. Park up in the attractive town square and you can admire (or smirk at – it is wonderfully phallic) the standing stone that was erected in honour of the pre-Christian deity Mannan. 'Clack' comes from the Gaelic for 'stone', which explains where the town's unusual name came from. Also nearby are the sixteenth-century tollbooth's belfry and the mercat cross. It is then a short stroll up the hill, past some modest houses, through a gate and suddenly you are standing proud on an open hilltop, with the handsome figure of the tower in front and the wide sweep of the river valley filling the horizon. To the west you can easily pick out Ben Lomond, where a raindrop falling on the western flanks will reach the Clyde; on its eastern side, the Forth. The fighty wee hills of Stirling lie in that direction too, then there are the wide meanders of the inner firth. Below your feet are wide fertile

'You know what I think the conservatory should look like?'

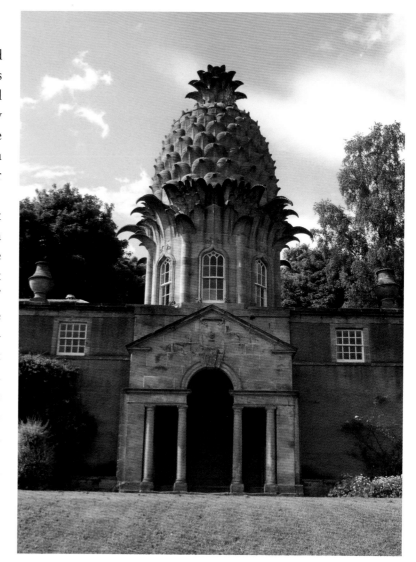

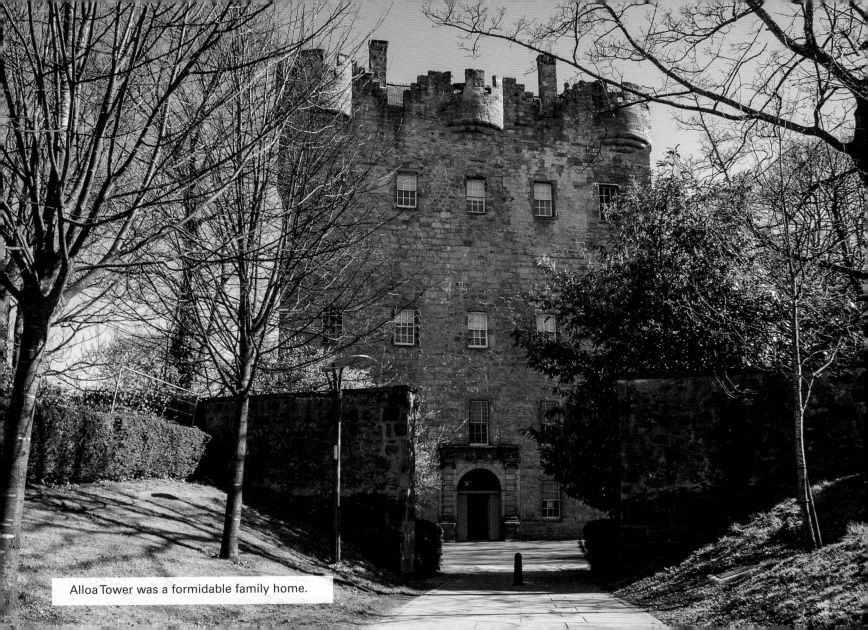

Alloa Tower was a formidable family home.

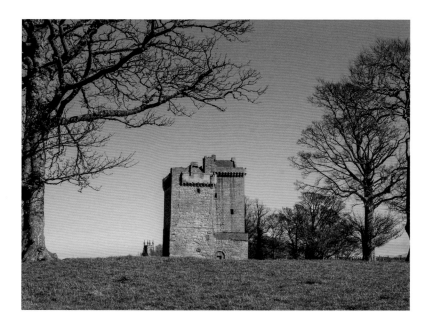

Clackmannan Tower stands far apart from the town.

fields and then the river heads on east towards the bridges at Kincardine and the even mightier crossings at Queensferry. The view of agriculture and industry shows why it can be tricky to get down to the riverbank itself in these parts and goes a long way to making up for that loss of access.

The tower itself is a terrific landmark that was built and lived in by descendants of Robert the Bruce. The last family resident was Lady Catherine Bruce, who called this home until her death in 1791. She was a highly eccentric lady and a staunch Jacobite who goes down in history as the woman who knighted Robert Burns. The poet stopped by one summer's day in 1787 and she took down the sword of her illustrious ancestor, Robert Bruce, and duly knighted our national bard with it. I'm guessing a drop or two of whisky was involved in that episode.

Which was the first railway bridge over the Forth? The world-famous cantilevered one at Queensferry, right? Wrong – it was the Alloa swing bridge, 35 miles upstream. The 1,615-foot-long wrought-iron structure was completed in 1895, five years ahead of its more celebrated sibling. It was built to take a branch of the Scottish Central Railway over to Alloa, to connect with the Stirling and Dunfermline Railway, and was in regular use until 1968. Its 145-foot-wide steam-powered swinging section was removed a few years later, along with the spans. The piers still stand though, offering a spectacular panorama over to the Ochils – unknown to travellers who whoosh by on the M9. A spur of railway line that ran to the Royal Navy's Bandeath armaments depot at Throsk continued to be used until 1978. This depot is now an industrial estate, although many of the original munitions storage bunkers remain, as does a loading crane beside the river.

From Stirling a railway line plays tag with the great bends of the meandering inner firth, heading east for Alloa. It used to be possible to board trains at Alloa station bound for Dunfermline, Stirling, Falkirk,

Edinburgh and even more exotic parts. However, the last passenger train departed in 1973 and the lines slumbered. A connection for freight was kept open: Longannet power station's greed for coal demanded regular coal trains. However, this put increasing pressure on the Forth Bridge, a heavily used passenger route. In 2008 the Stirling–Alloa–Kincardine rail link was reinstated. The reopened 13-mile line proved a triumph, with almost three times as many passengers using it as were predicted. Its popularity could help herald a new Golden Age of rail; it certainly helped the Borders Railway project get the go-ahead. Indeed, with the impending closure of Longannet there have been calls for passenger services to continue eastwards when the coal trains cease to run. The whole route through to Dunfermline, and hence Edinburgh, would be once again opened up to passenger trains along the north shore of the Forth.

The true scale of Longannet can be difficult to grasp at first glance, but it is a brute of a power station. Its chimney stack towers 600 feet over the River Forth, the waters of which it sucks up into its flaming innards for cooling. It was the largest coal-fired station in Europe when it first fired into action in 1970 and its generating capacity of 2,400 megawatts is the still highest in Scotland. It's also the twenty-first most polluting power station in Europe, devouring 4.5 million tonnes of coal each year and spitting out 4,350 tonnes of ash per day. In this more climate-aware era it's no wonder it is scheduled for closure.

The old belfry, mercat cross and 'clack' stone of Clackmannan.

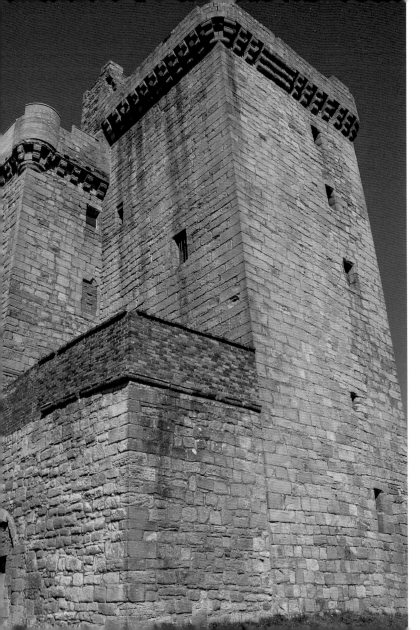

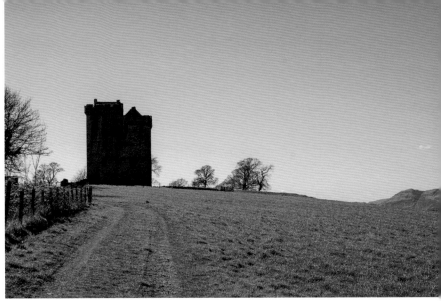

A lovely spot for an enormous tower house.

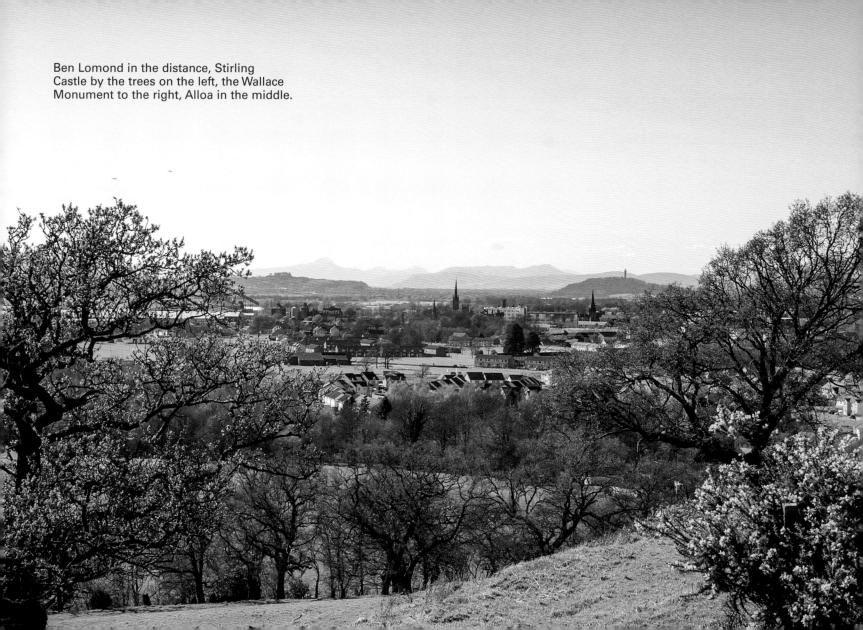

Ben Lomond in the distance, Stirling
Castle by the trees on the left, the Wallace
Monument to the right, Alloa in the middle.

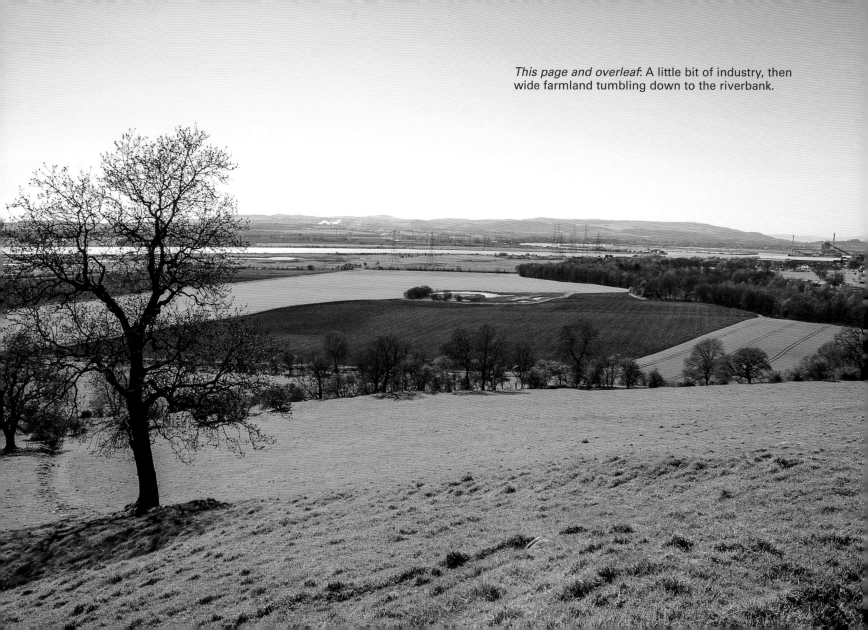

This page and overleaf: A little bit of industry, then wide farmland tumbling down to the riverbank.

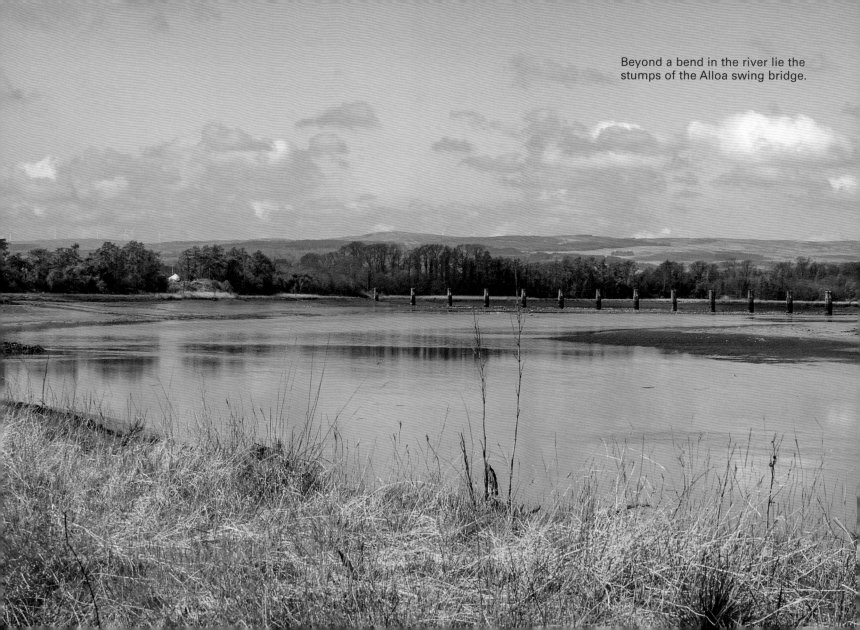

Beyond a bend in the river lie the stumps of the Alloa swing bridge.

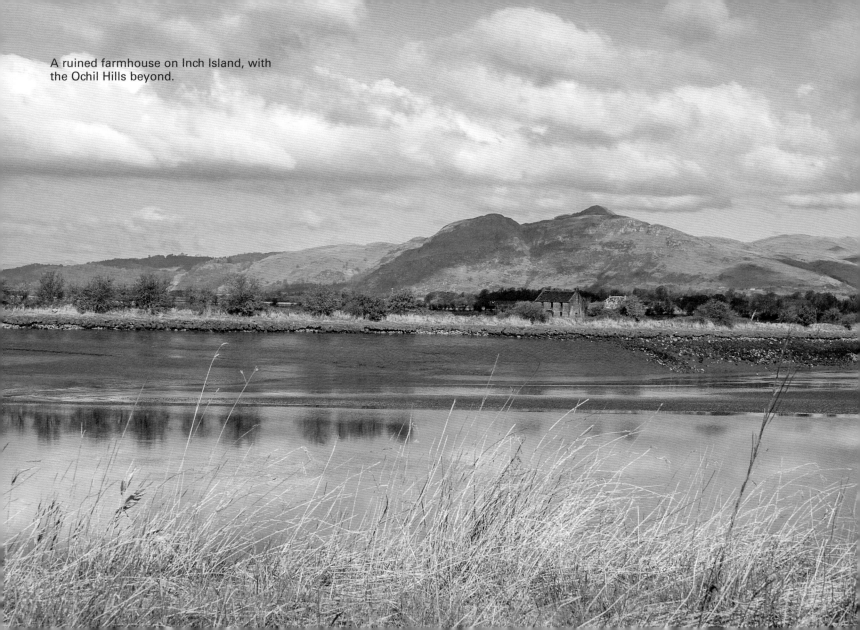

A ruined farmhouse on Inch Island, with the Ochil Hills beyond.

The Kincardine Bridge

Regular Edinburgh–Fife commuters refer to this bridge with an expletive in front of its name, thanks to the fact that when bad weather closes the Forth Road Bridge you are diverted 15 miles out of your way to cross the river here. Which is a shame, because it is a fine crossing.

It was a long time coming The Forth hadn't had a wholly new road crossing east of Aberfoyle for several hundred years. It finally got this one in 1936, complete with a central swinging section to allow big ships to sail upstream to the harbour at Alloa. It was then the longest swing bridge in Europe. However, this flexibility wasn't needed when the ships grew too big to negotiate the river bends to the west, and the bridge swung open for the last time in 1988. Road traffic was booming, though, to the point where it was seriously testing the sanity of local residents. In 2008 the strain was relieved with the opening of the nearby Clackmannanshire Bridge.

This 0.75-mile-long structure isn't actually in Clackmannanshire at all, spanning the river from Fife to Stirlingshire. However, the north road does quickly run into the county it is named after, so it sort of makes sense. Look up as you drive over and you'll see that the bridge itself is crossed by high-flying electricity lines. This is the 400-kilowatt Forth Crossing, and its wires are slung from the tallest electricity tower in Scotland. The northern tower is 450 feet tall while the tower at the southern end stands at a mighty 505 feet.

Fallin

'Dull and uninviting' is not a description that most pubs would want to lay claim to. But the Gothenburg Bar in Fallin was designed to be exactly that. In the 1850s every Swedish adult was downing an average of 34 litres of spirits a year. To counter this boozing bonanza the city of Gothenburg awarded only one licence for spirit retailing to a special trust. This body was charged with ensuring drink consumption was minimised. It set up pubs that were deliberately spartan in their decor,

A dour boozer by design.

with no credit on offer and the sale of spirits generally discouraged. Betting, gambling and games – even dominoes – were all banned. All profits were spent on projects for the good of the community.

This 'pub cooperative' was such a success that it spread throughout Sweden and further afield to Scotland. Dozens of 'Goths' (as these pubs were known) were built, particularly in the mining areas of the Lothians, Fife and Ayrshire. The pubs' profits have been spent on libraries, museums, parks, bowling greens, cricket grounds, cinemas, community centres and charities. Many of these facilities are still enjoyed today and there are still several 'Goths' in Scotland, although Fallin's is one of only four that still adhere to the Gothenburg System.

Bo'ness

This is one of the few towns in Britain whose nickname is featured on signs – its proper name is Borrowstounness. This was where the eastern end of the Antonine Wall met the sea, and there is still a section of wall and a Roman fortlet visible in the grounds of Kinneil House, to the west of the town. In 1936 this magnificent house had been abandoned by its owners, the Hamilton family, and was actually in the middle of being knocked down when some murals were discovered. They were impressive enough to earn the building a reprieve from the wrecking ball and it has been in the care of Historic Scotland ever since. There is a small, ruined cottage in the grounds where James Watt worked on his steam engine.

Bo'ness made its money from its port, which was constructed in the sixteenth century. Millions of tonnes of local coal were shipped out of here until the docks closed in 1959. Clay mining and industrial salt making, which involved evaporating seawater over coal fires, also thrived here. Until 1970 there was a flourishing ship-breaking yard at Bo'ness. Ships to be dismantled would be manoeuvred to the far (north) side of the river and then, on a high spring tide, steamed across with all speed to drive them as far as possible up the beach. They would be cut apart where they lay.

Although most of the town's industry has long departed, you can still get a little flavour of what it was like here in years gone by, thanks to the Bo'ness and Kinneil Railway. Run by the Scottish Railway Preservation Society, it has over 5 miles of track (between Bo'ness and Manuel Junction, via Kinneil and Birkhill) and many wonderful locomotives. It may look like the society has preserved an existing station and workshop complex, but almost everything that you can see here was built from scratch or brought here from elsewhere. The original Bo'ness Station was flattened to build a road in 1956.

There is one industrial legend still going strong: the 200-year-old Bo'ness Iron Company continues to produce world-class metalwork. Its castings include the cannons at Edinburgh Castle, refurbished panels on Westminster Bridge, restoration of North Bridge in Edinburgh and the Royal Mews canopies at Buckingham Palace.

Bo'ness is also home to the oldest picture house in Scotland – the beautiful Hippodrome Cinema, which was built in 1912. After a sad turn as a bingo hall in the 1970s and a ruinous abandonment in the 1980s, it has recently been refurbished to its full glory.

The Tunnel under the Forth

The tall spire of Old Kirk at Bo'ness is a well-known landmark to locals, and in 1964 its prominence made it feature in one of the most amazing yet least known, construction projects ever undertaken in Scotland: the tunnel under the Forth.

Both the north and south shores of the Forth were once dotted with collieries. Pits were dug on land and then the coal seams were followed out deep under the firth. After a major outfitting in the 1950s, the Kinneil colliery at Bo'ness was state of the art – the most modern mine in the land. Valleyfield, directly across the firth on the north shore, was far less efficient, having changed little since opening in 1908. So the coal board came up with an ingenious plan: connect the two undersea pits and take the Fife coal out through the more streamlined processing facilities on the Lothian side of the water at Bo'ness.

Above: A busy day on the Bo'ness and Kinneil Railway – this 'tilt-shift' photo makes the scene look model-like.

Below: The Bo'ness Hippodrome.

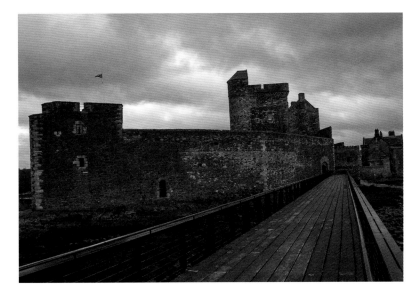

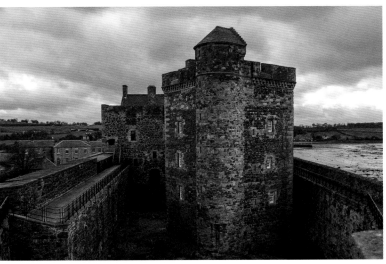

There were no GPS or laser theodolite systems, which is where the Old Kirk came in. Along with Blair Castle on the opposite bank, it was used as a visual marker for the tunnelling operations. Surveyors checked progress by lowering piano wire down the shafts, taking reading after reading to the finest of measurements.

The collieries were 3 miles apart and the connection between them took twenty-seven men and eighteen months to complete. When the two teams of diggers finally met, 1,640 feet below the choppy waters of the firth, they were only 2 inches out of perfect alignment.

Valleyfield did indeed receive a shot in the arm from the link-up, but this only lasted until 1978. The undersea geology proved more unpredictable than had been thought, and the mine was forced to close. Kinneil's miners stopped digging (as they did at many British pits) in 1982.

The head of engineering on the project, Alistair Moore, remains the only person who can claim to have walked to Fife and back under the sea. It's a record he's likely to hold for the foreseeable future.

There is nothing to be seen of the tunnel today. The collieries were both demolished, and the shafts were filled in with hardcore and then capped with concrete. The tunnel itself will by now be filled with water or simply collapsed, its iron pit props buckled by settling rock layers.

Above and below: 'The ship that never sailed' – Blackness Castle.

Culross

How did our ancestors really treat witches? What was the purpose of a tollbooth? Why was royal burgh status so important to a town? You can find the answer to all these questions and more simply by walking the streets of Culross (pronounced 'coo-russ'). There isn't a more perfectly preserved seventeenth-century burgh town in the country.

It seems ancient to us, but Culross was built on innovation. The world's first coal mine to extend under the sea was sunk here in 1575, and the black riches dug out from the pit paid for the development of the town we see today. The red roof tiles visible here and in other Fife coastal towns are evidence of this coal-mining past: ships that delivered local coal to the Low Countries brought back Dutch tiles as ballast. Culross's fine Town House was built in 1626 to levy customs and manage the market. It had a tollbooth and prison especially for women accused of witchcraft. Royal burgh status gave the town a local monopoly on foreign trade and Culross added salt panning and metalwork to its roster of lucrative industries.

The town's success declined in the eighteenth century and it was crumbling into dereliction in the Victorian era, but since the 1930s Culross has been lovingly cared for by the National Trust.

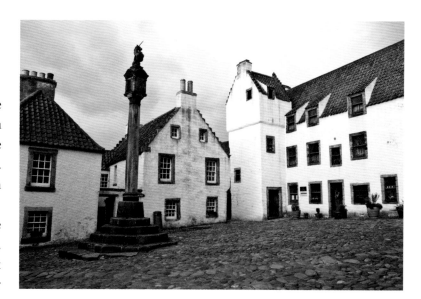

Above: The mercat cross at Culross.

Below: The *Duchess of Sutherland* steams past Culross; the line runs right along the firth's shore.

Perhaps the most famous local resident was Thomas Cochrane, a remarkable and rebellious man who had a dashing naval career. After being discharged from the Royal Navy in disgrace in 1814 for stock exchange fraud, he went on to command the navies of Chile, Brazil and Greece as those countries fought for their independence. Cochrane was also an inventor and along with Marc Isambard Brunel he co-patented the tunnelling shield that was used in building the famous Thames Tunnel – the world's first ever passage constructed under a navigable river.

Rosyth

'This looks like an easily defensible island,' thought someone wealthy 550 years ago, and so they built a castle upon it. And for centuries Rosyth Castle was surrounded on all sides by water that kept its inhabitants, for the most part, safe. By the start of the twentieth century its defences were obsolete, but its position was useful in a different defensive way. Rosyth was close to Edinburgh and the vital Forth Bridge and had easy access to the North Sea. The Royal Navy was then doing the shipbuilding version of hitting the gym and scoffing steroids in a bulking-up battle with Germany.

So in 1909, the castle found itself once again surrounded on all sides, but this time by the Rosyth Naval Dockyard, which was built on 1,300 acres of largely reclaimed land.

Rosyth has had an eventful history. Many of the fifty-two German ships that were scuttled at Scapa Flow in 1919 were later salvaged here. From 1984 the Royal Navy's nuclear submarine fleet was refitted here. Its current job – a truly spectacular one – is as the assembly yard for the new Queen Elizabeth-class aircraft carriers.

These two vessels, HMS *Queen Elizabeth* and HMS *Prince of Wales*, have been built in sections in six different shipyards around the UK. These sections were then floated to Rosyth and welded together to create the mightiest-ever ships to sail in the Royal Navy. *Goliath*, the strongest gantry crane in Europe, is doing the heavy lifting, hoisting lumps of ship weighing up to 1,000 tonnes into place.

The carriers have two gas turbine engines that are the most powerful ever fitted on a ship. Each produces 36 megawatts – this is enough to power a town the size of Guildford (although, presumably, not enough to whizz it round the North Sea at 25 knots). The ships will be home to 679 crew, with berths for a further 1,600 troops who don't mind their personal space being squeezed a bit.

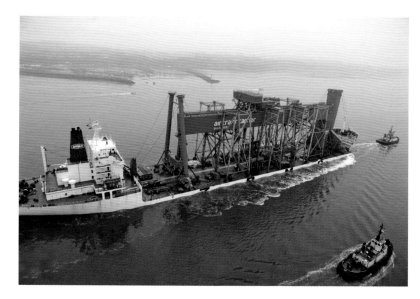

Above: Building the aircraft carriers meant ordering the UK's biggest crane, which arrived by river.

Right: Rosyth Castle, once surrounded by water, now surrounded by docks.

The biggest Meccano set in the world – the chunks of HMS *Prince of Wales* are joined together.

And the model is complete – HMS *Queen Elizabeth* in Rosyth Dockyard.

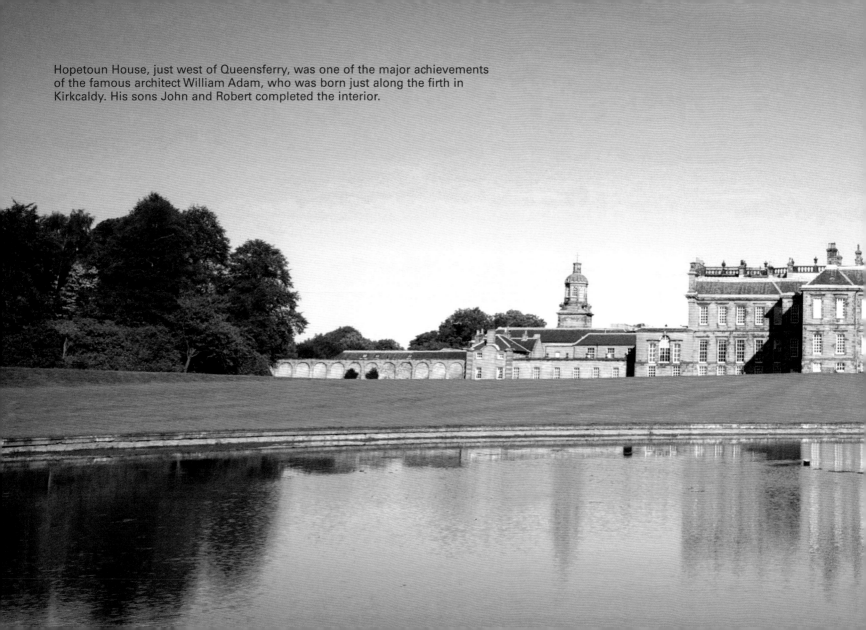

Hopetoun House, just west of Queensferry, was one of the major achievements of the famous architect William Adam, who was born just along the firth in Kirkcaldy. His sons John and Robert completed the interior.

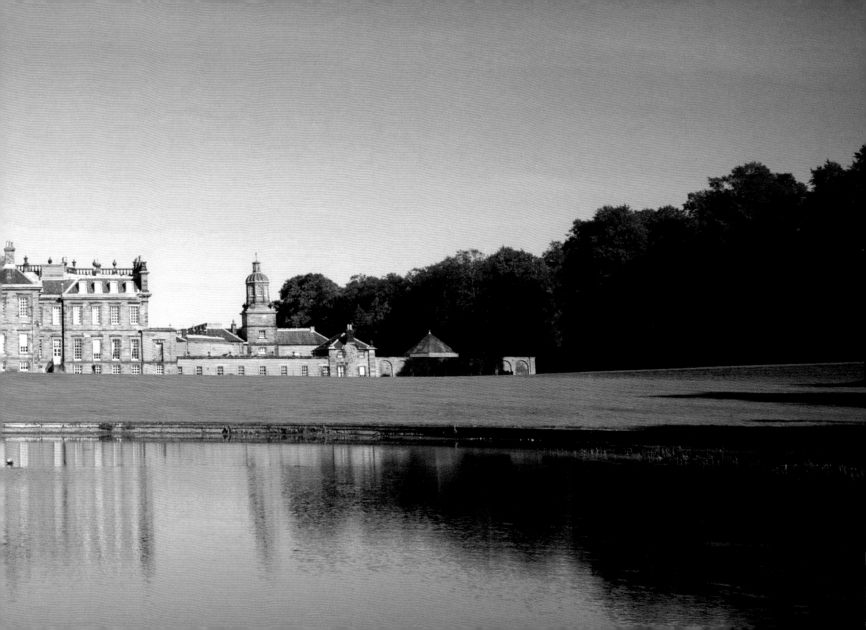

5

FORTH CROSSINGS

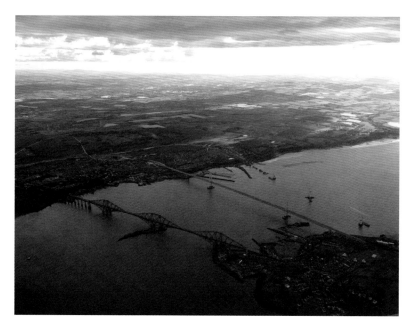

Progress on the third bridge at Queensferry, taken in May 2014.

The Forth Bridge is one of the world's most recognisable landmarks and a milestone in engineering history. It opened in 1890 and is still going strong 125 years later. The Forth Road Bridge transformed transport and business life in south-east Scotland when its four free-flowing lanes replaced a dainty car ferry in 1964. As this book goes to press a third major bridge, the impressive and elegant Queensferry Crossing, is nearing completion. Over the centuries there have been numerous other attempts to traverse the waters between Edinburgh and Fife – many of them ingenious, others downright bizarre.

Sea Crossings

Boats have crossed the firth since at least the sixth century and it was in the eleventh century that a regular ferry service was established. Queen Margaret was a pious monarch (and later saint) who founded a regular ferry service so that pilgrims heading to the shrine of St

Andrew in Fife could cross in safety. This they did, in huge numbers. After Margaret died in 1093 she made one last journey by ferry here, on her way to be interred in Dunfermline Abbey. Her son, King David I, later awarded the ferry rights to the abbey.

In the centuries that followed the 'Queen's ferry' became established as the main – but by no means the only – crossing of the firth. The ferry was famously used by Mary, Queen of Scots, after her escape from Loch Leven Castle to the north. It was a key link in a major travel route up and down the country's east coast. If you think Virgin Trains are bad, be glad you didn't have to make the journey in the eighteenth century; a rattling coach would dump you at the Hawes Inn for a restless night in a flea-bitten bed. The boatmen that took you over the firth in the morning weren't regulated, trained or even particularly good sailors – their vessels were overladen and their travellers overcharged. Most were extremely glad when they stepped out onto Fife's shore.

The first car ferry, *Robert the Bruce*, entered service in 1934. It could carry 500 passengers and twenty-eight cars. Over the next thirty years, three further vessels joined the ferry 'fleet', the largest of which could carry forty cars. By 1964 the four ferries together made 40,000 trips and carried 900,000 vehicles a year. Their replacement, the Forth Road Bridge, had 4 million crossings in its first year and today carries around 24 million vehicles every year.

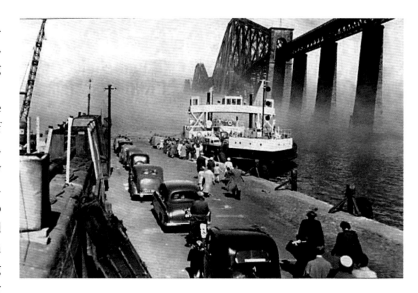

A bit less traffic crossed the firth in those days.

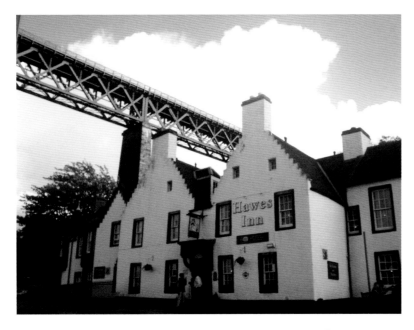

The Hawes Inn with the southern approach to the Forth Bridge towering above.

The Hawes Inn

Just then we came to the top of the hill, and looked down on the Ferry and the Hope. The Firth of Forth (as is very well known) narrows at this point to the width of a good-sized river, which makes a convenient ferry going north, and turns the upper reach into a landlocked haven for all manner of ships. Right in the midst of the narrows lies an islet with some ruins; on the south shore they have built a pier for the service of the Ferry; and at the end of the pier, on the other side of the road, and backed against a pretty garden of holly-trees and hawthorns, I could see the building which they called the Hawes Inn.

Kidnapped, Robert Louis Stevenson

With so many travellers arriving at the pier here it was inevitable that a pub would be established, and the Hawes Inn has been serving thirsty pilgrims since 1793. Since 1890 it has also been giving visitors a neck-crackingly good view of the Forth Bridge. Celebrated author Robert Louis Stevenson, who was born in Edinburgh, often visited the Hawes Inn, and he conceived his famous novel *Kidnapped* while staying in Room 13 in 1886. Sir Walter Scott also wrote the pub into a novel, *The Antiquary*. When the Forth Bridge was being built, the staff in the Hawes Inn would line 200 pints up on the bar ready for the end of a shift. The 'briggers', the men who built the bridge, were a notoriously thirsty crew.

Sunken Treasure

Traversing the Forth doesn't always go smoothly – there are about 500 wrecks scattered on the bed of the firth. These include trawlers, coal steamers, schooners, submarines and several aircraft. The largest

ship sunk in the Forth was the 18,000-tonne luxury Cunard liner HMS *Campania*, which was built in 1893 and used as an aircraft carrier during the First World War. She once held the Blue Riband for crossing the Atlantic, but while moored off Burntisland in 1918 her anchor chain broke in a storm and she ploughed into several other vessels (including *Royal Oak, Glorious* and *Revenge*) before sinking.

By far the most celebrated ship under the firth's waters is the *Blessing of Burntisland*. In the seventeenth century, this humble wooden ferry shuttled travellers between Burntisland and Leith. However, it was downed in a ferocious storm in 1633, to the particular dismay of King Charles I – the ferry was carrying twenty carts' worth of treasures from his hunting palace at Falkland. The wealth that disappeared under the waves was incredible: gold and jewels, a 280-piece silver dinner service commissioned by King Henry VIII, as well as tapestries and silks for Charles's coronation tour of Scotland. Thirty courtiers and servants also perished. The lost cargo was worth around £100,000 – about one-sixth of the value of the entire Scottish exchequer. Charles watched helplessly from the deck of his flagship, the *Dreadnought*, as the whole tragic event unfolded. He was so upset he brought his coronation tour to an early end and returned to London. Sixteen years later the unlucky monarch lost something even more precious than his silverware: his head. Many divers and survey vessels have searched for the wreck, but the river keeps the secret of this treasure ship to this day.

Tunnels

There have been several attempts to tunnel beneath the Forth, with the first serious one in 1617. Sir George Bruce was a coal merchant from Carnock, Fife, who dug into a seam under the estuary. There was an exit from this mine on an artificial island a mile into the channel, from which coal was loaded on to ships. King James VI and I is said to have popped by to visit this early industrial marvel, but got paranoid and accused Sir George of enticing him underground to murder him. The mine was later flooded and it has never been relocated.

Plans for tunnels were also drawn up in the 1790s, in 1805 and 1891, but didn't make it as far as construction. In 1954, ten years before the Forth Road Bridge opened, there was a proposal tabled for a 'Forth Tube'. This would be a 2,800-foot-long reinforced concrete traffic tunnel. Planners plumped for the bridge. A tunnel was again discussed when the Forth Road Bridge's accelerating decay was discovered. A study concluded that a bridge would be much cheaper, and so the cable-stayed bridge got the green light as the new Queensferry Crossing.

Train Ferry

The railway network spread like ivy across Britain in the 1840s and many of the long- distance lines that we travel on now were built then.

Trains could travel from London to Edinburgh via Carlisle in 1848, and up the east coast two years later with the completion of the impressive Royal Border Bridge at Berwick-upon-Tweed. Next stop, Dundee and Aberdeen – but there was a problem. The firths of Forth and Tay were far wider than anything previously bridged. A circuitous route inland via Stirling and Perth was built until the technology could evolve far enough to make Forth and Tay bridges feasible.

This detour was very time-consuming, and passengers preferred leaving their train at Granton to take the ferry over the water and pick up a train on the north side. However, trans-shipping freight in this way was far too expensive and troublesome. So in 1850 an up-and-coming engineer called Thomas Bouch came up with an innovative solution – a floating railway.

Trains would arrive at Granton and load their wagons directly onto boats that had been fitted with railway tracks on their decks. The boat would then travel the 5 miles over the estuary to Burntisland, where the wagons would be winched off onto tracks on the docks and hooked up to a locomotive to continue their journey north. Floating slipways ensured that the wagons could roll onto the boats whatever the level of the tide. This was the world's very first roll-on/roll-off train ferry. Subsequently, many others were built around the world, including the one that ran from Dover – Dunkirk.

The Granton–Burntisland train ferry continued successfully until 1890 when the Forth Bridge opened, making the service redundant. Bouch went on to be knighted for his design of the Tay Bridge, the longest bridge in the world when it opened in 1878.

After the bridge collapsed the following year, killing 75 people, his reputation was shredded and he died in disgrace shortly afterwards. Bouch had also designed a bridge for the Forth, and a foundation stone had been laid; the disaster meant that Bouch's Forth Bridge design was promptly cancelled.

Hovercraft

In 2007 a trial hovercraft service was introduced by Stagecoach between Kirkcaldy and Portobello. It was fun and successful: 32,000 passengers hopped aboard for the twenty-minute whizz across the water in the two week trial, but Edinburgh City Council, in their wisdom, refused planning permission for a terminal.

Hot-Air Balloon

The Montgolfier brothers first sent a manned hot-air balloon heavenward in Paris in 1783, and two years later the craze reached Scotland. On 5 October 1785 a pioneering Italian aeronaut called Vincenzo Lunardi launched himself in a hot-air balloon from the grounds of George Heriot's School, in Edinburgh. The wind carried him northwards and he made a spectacular first air crossing of the Firth of Forth. Lunardi was the first to see the river from above, and he wrote that he could see towns as far west as Glasgow and Paisley, 'as

well as all those on both sides of the Forth, the meanders of which, with the highways and rivers in the adjacent country, had exactly the same appearance as if laid down on a map'. Lunardi returned to earth 46 miles from his starting point, in Coaltown of Callange near Ceres, Fife. A plaque marks the spot. Balloon-shaped 'Lunardi bonnets' towering up to 23 inches in height atop ladies' heads subsequently became very fashionable among Scottish women. Robert Burns mentions these constructions in his poem 'To A Louse'.

Bridges

A Roman coin issued in AD 209 shows a pontoon bridge across a wide river; some historians believe this commemorated a military campaign in Scotland and that the bridge was over the Firth of Forth. The first serious proposal for a permanent bridge across the Forth at Queensferry came in 1740, but it would be another 150 years before a crossing was actually constructed. In 1863 some work was done on a bridge further up the Forth at Charlestown. This plan was abandoned when engineers placing the foundations were unable to reach bedrock beneath the silt on the riverbed, despite digging for over 230 feet.

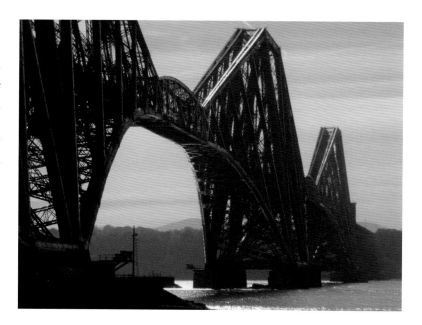

Above: The bridge's 53,000 tonnes of steel look impressive close up.

Below: The hovercraft was so popular it even got spectators.

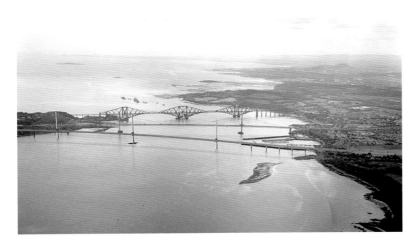

How all three bridges will look when the Queensferry Crossing is finished.

The Forth Bridge

The Forth Bridge is a flat-out masterpiece. It had to be: the much-vaunted Tay Bridge collapsed in 1879, taking a train and seventy-five souls to their doom. This disaster rocked the engineering world and ruined the reputation of the bridge's designer, Sir Thomas Bouch. Work had already started the previous year on a Forth Bridge designed by Bouch. This was immediately cancelled.

A new design, which would be beyond conventional ideas of strong, was demanded. The railway company turned to Sir John Fowler, the chief engineer of the world's first underground railway (London's Metropolitan Railway), and Sir Benjamin Baker, another noted railway engineer who also built the first Aswan Dam. They delivered ... and then some.

The Forth Bridge took eight years to build and cost £3.2 million, as well as the lives of 57 of the 4,000 workers. Its unique design features three giant double cantilevers linked together and balanced by 1000-tonne counterweights at the far outer ends. It was the first large structure in Britain to be made of steel; the Eiffel Tower, built at the same time, uses wrought iron. The doomed Tay Bridge had used cast and wrought iron; the towers are 361 feet high and trains run 158 feet above the river. There are 54,000 tonnes of steel and 6.5 million rivets in the bridge. It runs for 8,296 feet and was the longest cantilever bridge in the world until the Quebec Bridge in Canada surpassed it in 1917. It is still the second-longest single cantilever span. Before the bridge opened a railway journey from London to Aberdeen took thirteen hours. The route over the Forth reduced that to eight and a half hours. Up to 200 trains a day currently use the bridge and it is expected to stand for at least another 100 years. No wonder it was dubbed the Eighth Wonder of the World on its completion.

The expression 'painting the Forth Bridge' meaning a never-ending task is actually a misnomer. Although the bridge did have a permanent maintenance crew, they didn't immediately start again at the other side when they finished painting it – they would rather be repainting whichever areas were the most weathered.

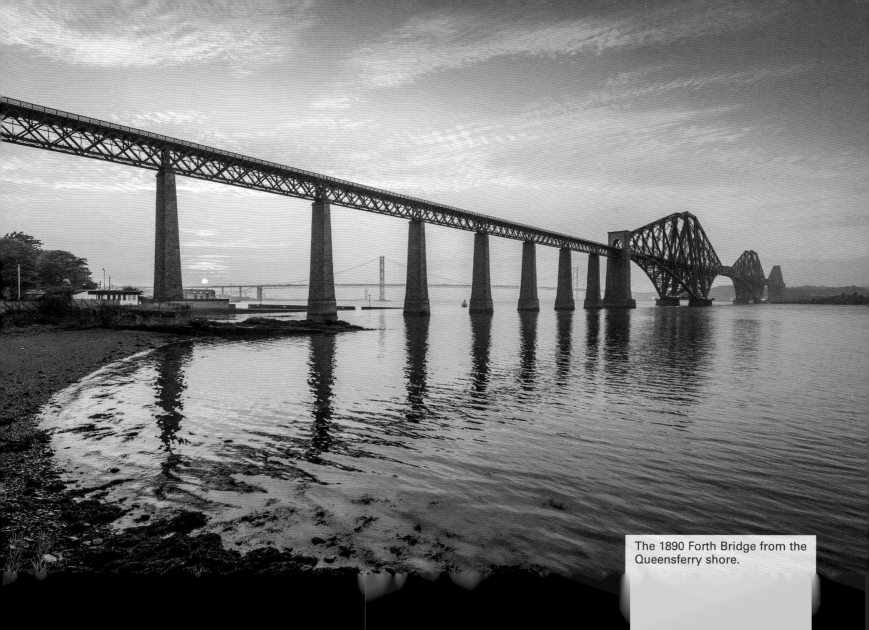

The 1890 Forth Bridge from the Queensferry shore.

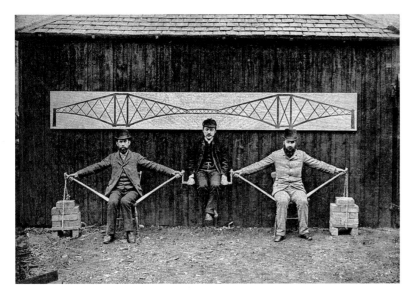

The repainting job of 2002, which used extremely weatherproof glass-infused paint, should last for twenty years.

Forth Road Bridge

Much like a boy whose older brother is both the captain of the football team and an academic genius, the Forth Road Bridge is a much-overlooked younger sibling. But it's still a fantastic bridge in its own right. The main span is 3,300 feet long, which made it the longest suspension bridge in the world outside of the United States, and the fourth longest overall, when it opened in 1964. The full length of the bridge is more than 1.5 miles and its towers stand 512 feet above high water. Meanwhile, 105 feet below high water its foundations drive down through the mud of the estuary bed to reach base sandstone.

The bridge's main cables are each composed of 11,618 individual high-tensile steel wires, packed into a bundle 23 inches thick. Laid end-to-end these wires would encircle the world one and a quarter times. The cables were 'spun' a few wires at a time by a machine that passed back and forth across the estuary. The completed cable was hexagonal in section, being compacted

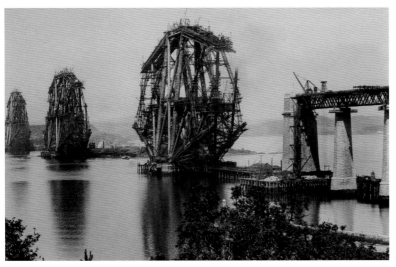

Above: 'The bridge's cantilever principle as demonstrated by Fowler, Baker and Japanese engineer Kaichi Watanabe.

Below: Construction progressing.

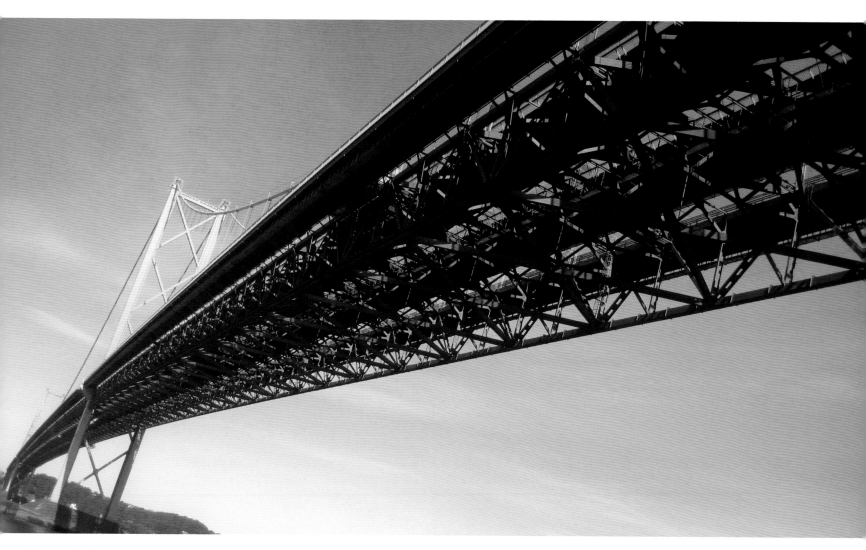

The road bridge zooms overhead.

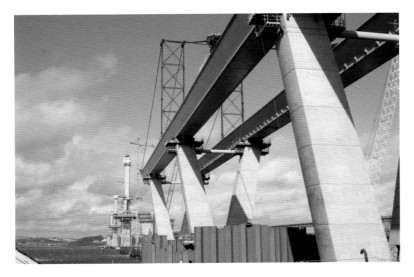

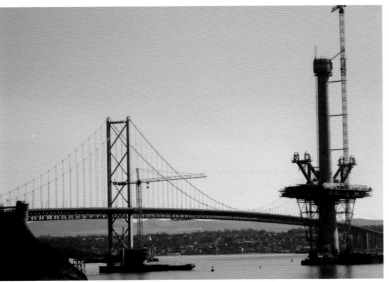

into the round shape we see today and wrapped laterally with galvanised wire. Red lead paste was added between the cables and wrapping wire for extra protection and the whole cable was then painted.

The entire meticulous operation cost £11.5 million and the bridge was forecast to last for 120 years. However, that was with a predicted load of 11 million vehicles a year. By the turn of the twenty-first century, the annual traffic figure was 23 million. Furthermore, the traffic was heavier: lorries now weigh up to 44 tonnes, an increase from the 24-tonne limit of 1964. A major bridge inspection found that the main suspension cables had been weakened by 8–10 per cent due to corrosion. With traffic levels set to increase further, a new crossing was clearly required.

The Queensferry Crossing

The new bridge, the Queensferry Crossing, will be another record-breaker: the longest three-tower cable-stayed bridge in the world, stretching for 1.7 miles. This is 400 feet longer than the existing road bridge. The bridge will use 30,000 tonnes of steel, with two main spans of 2,132 feet and two further spans of 1066 feet supported by three towers standing 679 feet high. It

Above and below: The Queensferry Crossing takes shape in 2015.

will cost £1.4 billion, a hundred fold increase on the Forth Road Bridge's price tag. The five-year construction project began in 2011. Humorous locals have dubbed it the 'Fifth Forth Bridge', counting the two at Kincardine.

South Queensferry

Tucked out of sight below the bridges, the town of South Queensferry is worth exploring. You can take boats out from the pier here to view the bridges and Inchcolm Island. Queensferry also hosts one of Scotland's most bizarre events: the Burry Man. A local worthy is covered head to foot in the sticky burrs of the burdock plant and paraded through town. His burry suit is so restrictive that he needs helpers to guide him; he fuels himself on his Herculean day-long adventure by sipping whisky through a straw. Nobody has a clue why this tradition exists. Almost as barmy is the 'Loony Dook', a mass swim in the waters of the Forth on New Year's Day.

A burry lunatic.

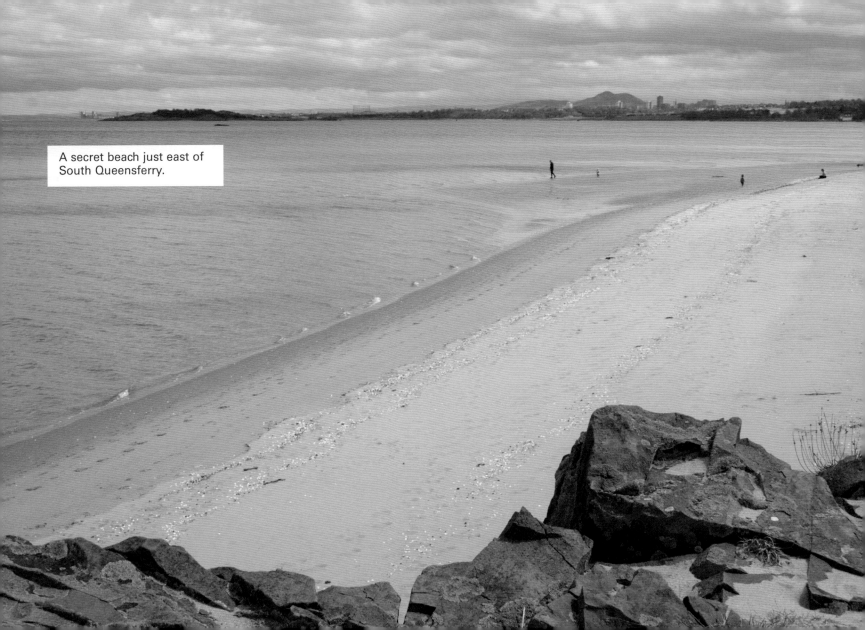
A secret beach just east of South Queensferry.

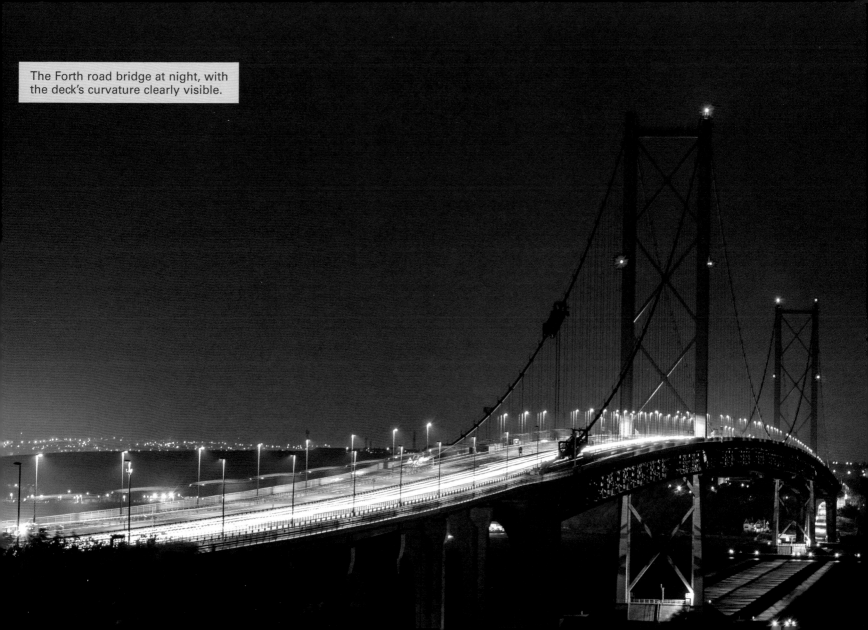

The Forth road bridge at night, with the deck's curvature clearly visible.

6

OUTER FIRTH NORTH

As it leaves the bridges at Queensferry behind, the Forth opens ever wider, becoming a large sea bay rather than a river: the outer firth. Almost every inch of both shores is packed with history to rival that of the smaller river.

To most people, North Queensferry is known as the landing point for the old ferry and the Forth Bridge and the home of the Deep Sea World aquarium, one of the largest in Britain. But just round the corner from the aquarium is a large and very successful quarry, the stone from which was used to build the docks at Leith and Liverpool and to pave many of London's streets. The aquarium is in fact in an old quarry hole. Gordon Brown, the former prime minister, has lived in North Queensferry for twenty years.

If you fancy exploring the delights of the northern shore on foot, you can pick up the southern and western end of the long-distance Fife Coastal Path at the Waterloo Memorial at the foot of the Brae. After looping around the end of Fife you'll eventually arrive at Newport-on-Tay.

Another small town with an important industrial past is Inverkeithing. This was once one of the biggest ship-breaking yards in the country. Many famous vessels were recycled into scrap here, and the Thomas Ward and Sons company's yards once handed 1,000 tonnes of scrap metal a day over to the country's steel producers.

Aberdour is famed for its castle and silvery beaches, and although its proximity to the Forth Bridge and its fine Victorian houses make it a commuter hotspot, it still retains a charming 'town that time forgot' feel. Before the railway came, many pleasure steamers crossed the Forth from Leith to bring day trippers to Aberdour Harbour. There is a short, concrete jetty on the west side of Hawkcraig Point; this was used during the development of radio controlled torpedoes during the First World War. The foundations of the radio hut can still be seen in the lea of the hill.

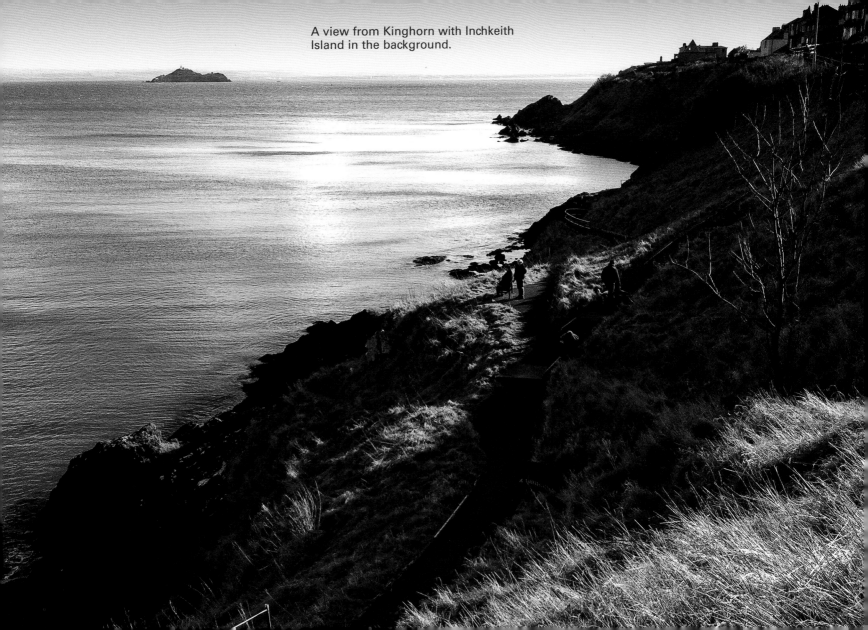

A view from Kinghorn with Inchkeith Island in the background.

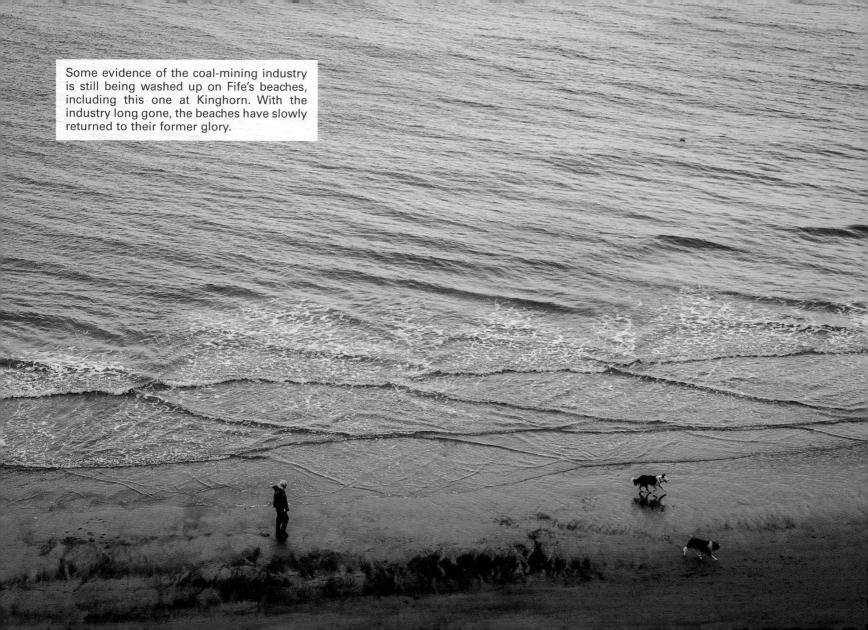

Some evidence of the coal-mining industry is still being washed up on Fife's beaches, including this one at Kinghorn. With the industry long gone, the beaches have slowly returned to their former glory.

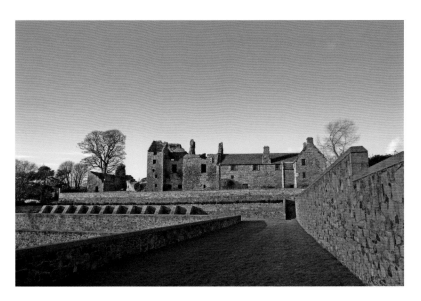

Aberdour Castle.

Burntisland

As a seaport, Burntisland was once second only to Leith in the Firth of Forth, and shipbuilding was an important industry in the town. In 1601, King James IV selected Burntisland as an alternative site for the General Assembly of the Church of Scotland. It was here that the notion of a new translation of the Bible was first mooted – a decade later this would be published as the King James Bible, probably the most influential single edition of a book ever published.

The first new parish church in Scotland after the Reformation was built here in 1592 – St Columba's. This has a unique shape: square with a central tower upheld on pillars and lined all round with galleries to allow the greatest number of people to be reached by the minister's words during the service. Burntisland is home to the second-oldest highland games in the world – a caber was first tossed here in 1652.

East Wemyss was typical of the many coal-mining towns that once flourished along this stretch of coast. It had the largest mine in Scotland in 1946, but the pit was closed after a fatal fire in 1967 and the town lost its main employer. The area around the town is blessed with 'weems', or caves; it has the highest concentration of caves in northern Europe. Its most famous son is Jimmy Shand, the band leader.

Kirkcaldy

From the early sixteenth century the establishment of a harbour at the East Burn confirmed the town's early role as an important trading port. The town had thriving salt, mining and nail-making industries and in the nineteenth century it specialised in one very particular product: linoleum. Linen manufacturer Michael Nairn branched out into making linoleum here in 1877, and Kirkcaldy was the world's premier producer until the 1960s. The numerous factories helped the town grow, but also gave it a famously

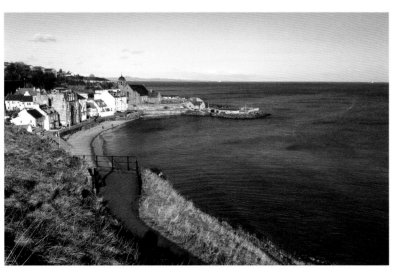

pungent aroma. There is still one large manufacturer, Forbo-Nairn, producing floor coverings in Kirkcaldy.

Kirkcaldy was nicknamed 'the lang toun' (Scottish for 'long town') thanks to its single 0.9-mile street, as seen on early maps. Today that street is closer to 4 miles long, as the burgh has swallowed its neighbouring suburbs of Linktown, Pathhead, Sinclairtown and Gallatown.

The town's football team, Raith Rovers, plays in the Scottish Championship; few people know that the club holds the British scoring record of 142 goals in 34 matches in the 1937/8 season.

Kirkcaldy has birthed more than its fair share of internationally famous people. The hugely influential social philosopher and economist Adam Smith was born here, and he wrote *The Wealth of Nations* at his mother's house at 220 High Street between 1765 and 1767. The architect and designer Robert Adam (and his father, William) were Kirkcaldy natives, as was the founder of *Standard Time*, Sir Sandford Fleming. But the town's most celebrated son is surely darts legend Jocky Wilson.

As the waters of the firth run east from the town they pass the ruins of Ravenscraig Castle, which has sat on its rocky tongue of land since 1460, when King James II built it for his queen, Mary of Gueldres.

Above: Burntisland docks now fabricate machinery and structures for the North Sea oil industry.

Below: The sun shines on Kinghorn, between Burntisland and Kirkcaldy.

The East Neuk

'Neuk' is a lovely onomatopoeic Scottish word meaning corner, and it particularly suits the towns at the eastern end of the firth's northern shore. They lie strung out along the coast of Fife like pearls on a chain. They really are gems – a mixed handful of precious stones, similar in their essence but each one bright and beautiful in its own manner.

Most people exploring this part of the world drive straight from the golf courses of Lundin Links to the town of Upper Largo without ever investigating its sibling, Lower Largo, which clings to the crinkled shore here like a particularly determined limpet. A lad called Alexander Selkirk was born in this ancient fishing village in 1676. A boisterous youth, he ran off to sea to become a buccaneer but was shipwrecked. He went down in history when Daniel Defoe wrote the book *Robinson Crusoe* about Selkirk's four-year spell as a castaway on an uninhabited South Sea island. Also visible here is the viaduct for the old railway that once looped round Fife.

Elie is a precious little place with an unmistakeable air of refinement about it. Fine houses perch round the curving bay like theatregoers in a grand circle, watching the sea's tempestuous performance. It would be remiss not to mention the Ship Inn, one of Scotland's best-situated pubs.

Above: Pittenweem on a fine Fife day.

Below: The moody, thoughtful sands at Elie.

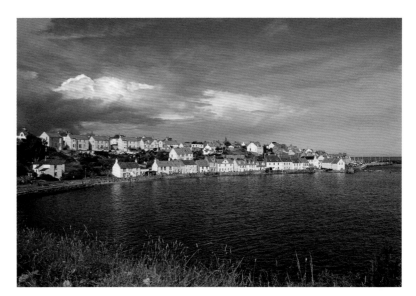

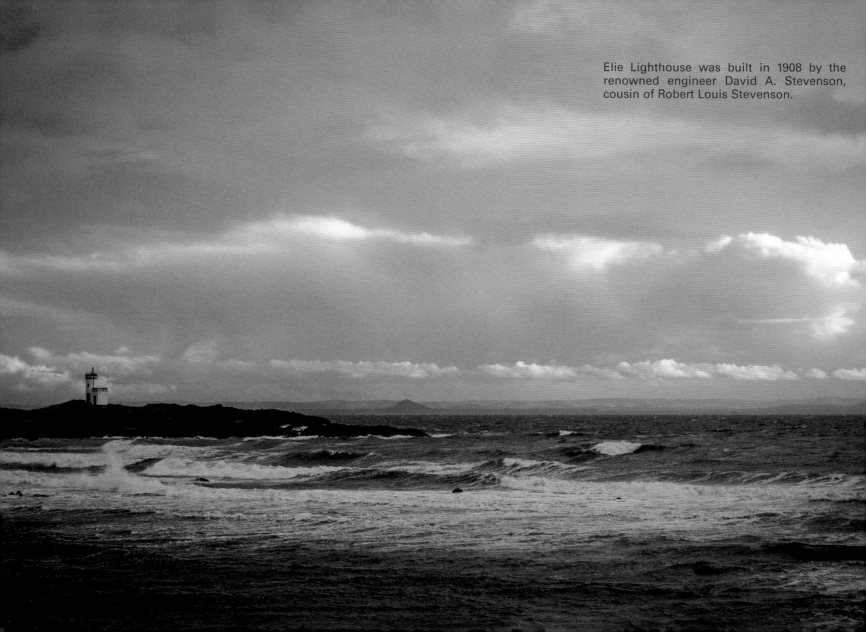

Elie Lighthouse was built in 1908 by the renowned engineer David A. Stevenson, cousin of Robert Louis Stevenson.

St Monans has an abundance of the architecture that the East Neuk is famous for: crow-stepped gables, forestairs and pan-tiled roofs. For centuries this part of the world did a roaring trade with the Low Countries and the Dutch traders would use pan-tiles as ballast in their ships. The locals decided they made a better roofing material than thatch. Curiously, St Monans has the church that is nearest the sea in the whole of Scotland – it's just 65 feet from the crashing waves.

Most of the East Neuk towns have working fishing boats, and it's at Pittenweem's fish market that they sell their catch. Prawns, crabs and clams are the main delicacies landed here. The bright houses cluster together round the harbour at odd angles and irregular heights, like seabirds jostling for the best position on the cliff.

Anstruther (pronounced 'Ainster' by the locals) lies in two halves athwart the Dreel Burn. This is the largest of the East Neuk towns on the Forth, and if all this travelling has made you peckish head to the town's fish and chip shop, which has been named the best in Britain. Many famous faces have been spotted patiently queuing here for their mushy peas, including Prince William, Clint Eastwood, Tom Hanks and Robert De Niro. No jokes about the Codfather, please. You can also find the fascinating Scottish Fisheries Museum on the front.

Cellardyke is contiguous with Anstruther, but it was once a separate and extraordinary village. Minuscule houses lean together over a road barely wide enough for cars to pass, with occasional gaps to the right showing just how close the waves are. Eventually you reach Cellardyke Harbour, the name of which comes from the Scottish for 'silver walls' (siller dykes). This was once so busy that the mass of landed fish hanging on the walls made the town seem to shine.

Crail is perhaps the most perfectly formed of all the East Neuk towns. The neat harbour, with its clutch of beautifully preserved buildings clustered around it, has been a honeypot for painters and poets for hundreds of years. It's a quiet place today, but in the sixteenth and seventeenth centuries Crail's Sunday fish markets were among the largest in Europe.

A painting of the church at St Monans by William Dow.

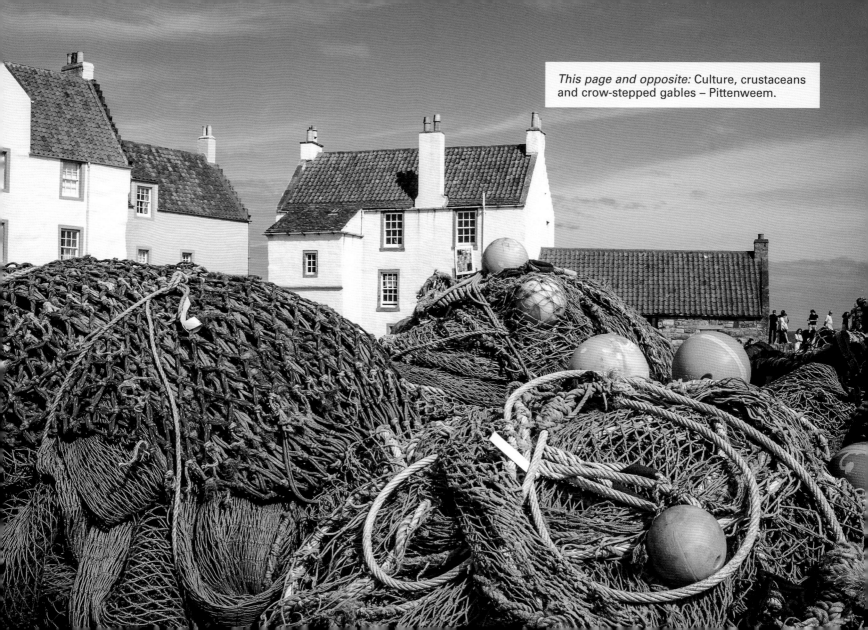

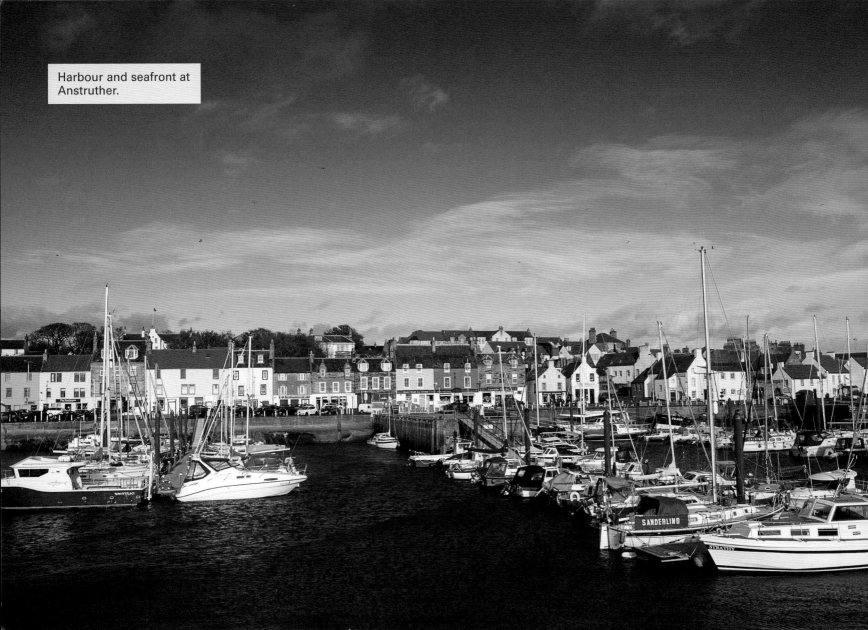

Harbour and seafront at Anstruther.

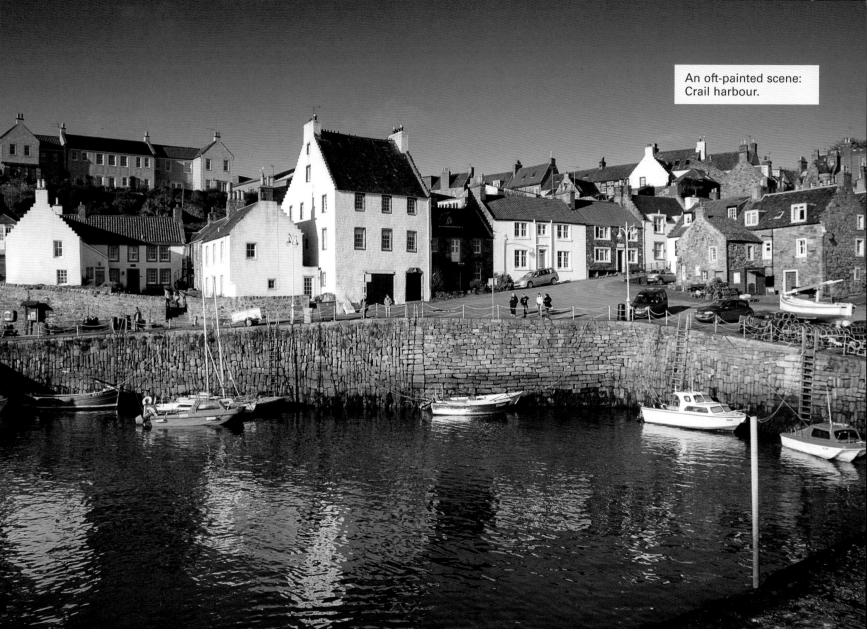

An oft-painted scene: Crail harbour.

LEITH AND EDINBURGH'S WATERFRONT

Leith is where Scotland's capital city meets the sea. Edinburgh's castle crag made a terrific fortress and citadel, but it lies 2.5 miles from the sea and the Water of Leith is not large enough to be navigable. This made Edinburgh the only city in Scotland not on a major waterway.

As Edinburgh's gateway to the oceans, it has seen a lot of historic events. Many kings and queens have landed here and Mary of Guise made the port the de facto capital of Scotland in 1560. She ruled the country as regent from Leith while her daughter, Mary, Queen of Scots, remained in France. Mary of Guise moved the Scottish Court to Leith, to a site that is now Parliament Street.

A Port Apart

Leith, then, served as the seaport for Edinburgh, although they remained separate and distinct places. Leith only officially became

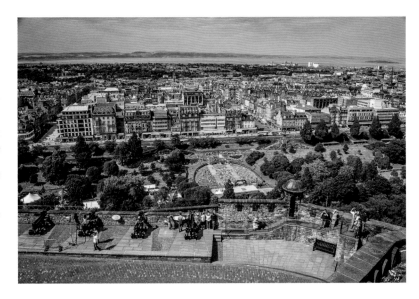

The Firth of Forth from Edinburgh Castle; originally miles from Leith, Edinburgh has now swallowed the port.

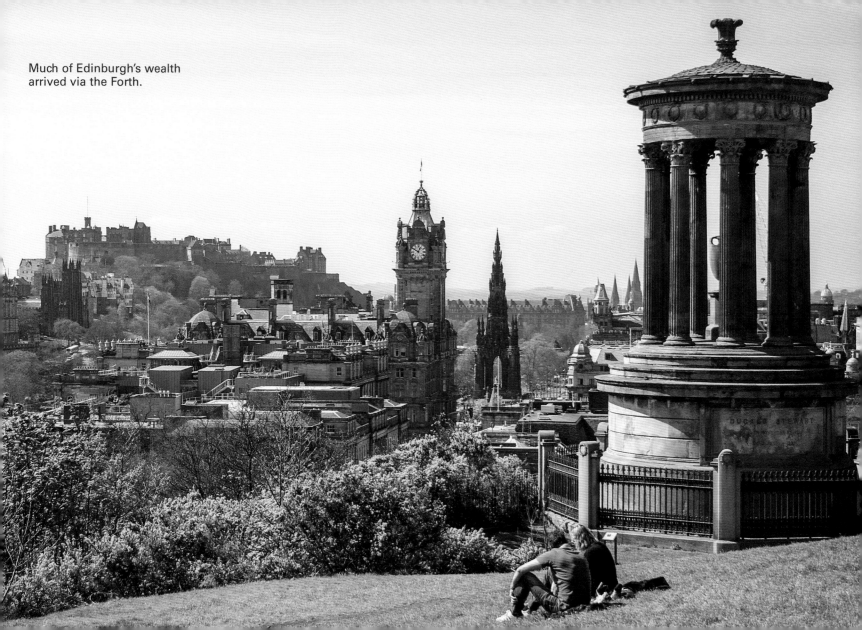

Much of Edinburgh's wealth
arrived via the Forth.

part of Edinburgh in 1920, and that was despite a plebiscite in which the people of Leith voted 26,810 to 4,340 against the merger. The famous City Limits pub (formerly the Boundary Bar) on Leith Walk marks where the dividing line was; drinkers could stand with one leg in Edinburgh and the other in Leith. Before the unification in 1920, Leith and Edinburgh had different licensing laws; the pub took advantage of this, with a bar and set of doors on each side of the line. Drinkers could quaff on the Edinburgh side until 9.30pm, then they had to adjourn to the Leith side to continue making merry. Leith had its own court, fire service and police force – criminals from Edinburgh who were nabbed in Leith had to be formerly handed over to the capital's police force. Thirsty coppers often did this in the Boundary Bar itself. To this day, proud natives of the port (for example, Irvine Welsh) will still identify themselves as 'Leithers'.

Shipbuilding in Leith

Leith was originally two small settlements: North Leith and South Leith, divided by the Water of Leith, which had no bridge. South Leith was the centre of trade, with wharfs, warehouses and merchants' houses. North Leith was a fishing village that later developed into a shipbuilding centre. The first dry dock in Scotland was built in Leith in 1720. King James I (1394–1437) established the first shipbuilding yard at Leith. His later namesake King James IV oversaw construction in Leith of his flagship the *Great Michael*. When launched in 1511 she was the largest ship afloat, with twice the displacement of her English contemporary, the *Mary Rose*. It was said that 'all the woods of Fife' went into her construction. As ships grew increasing larger in later centuries, they outgrew the shipyards of Leith, and Glasgow became Scotland's shipbuilding centre. However, many notable ships were still built here, including the SS *Sirius*, one of the first steamships to cross the Atlantic, and SS *Copenhagen*, one of the largest rigged ships ever built. In the twentieth century shipbuilding in Leith was mostly represented by Robb's, by far the biggest yard. Robb's made large numbers of Royal Navy warships, as well as tugs and dredgers, and it repaired thousands of vessels, particularly during the Second World War. It closed in 1983 and lay derelict for years. In this state it featured in the 1987 video for the song 'Letter From America' by The Proclaimers. The musicians' father had worked in the shipyard. Today the site is occupied by the Ocean Terminal shopping centre. There is one reminder of the site's past – a paint shed built from rivetted iron plates that still stands just to the north of the shopping centre.

The connection to the sea also lives on in the royal yacht *Britannia*, which is now permanently moored in Leith. You can see the style in which the royal family travelled during 696 foreign visits and 272 visits in British waters. In this time *Britannia*

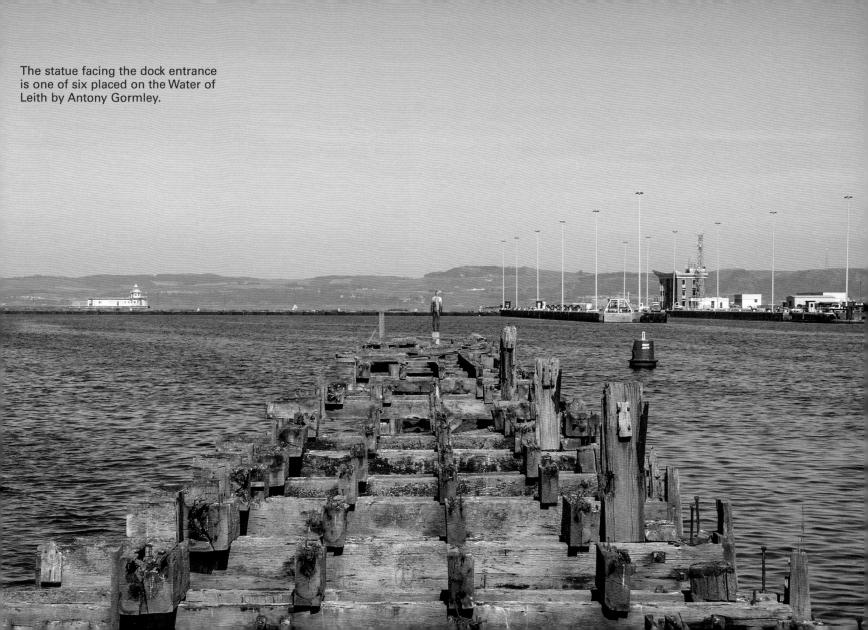

The statue facing the dock entrance is one of six placed on the Water of Leith by Antony Gormley.

Above left: *Britannia* berthed by the shopping centre that was once Robb's shipyard.

Above right: The building with the clock was once the Leith Sailors' Home; today it is the Malmaison hotel. The round tower used to be a windmill. Two of the barges are today owned by advertising agencies.

Left: An old Salvesen whaling harpoon on the Leith quayside. The swing bridge once carried trains to the docks now covered in apartment blocks.

steamed 1,087,623 nautical miles. In 2014 *Britannia* was named the UK's number-one landmark.

Leith's Cultural Contributions

Ever drunk a bottle of wine? Then you have Leith to thank. The world's most commonly used wine bottle design – parallel sides, round shoulders, thin neck – was designed in the Leith Glassworks. At its peak (about 1770), the factory shipped an amazing 1 million bottles per week to France and Spain.

Ever drunk vodka and lime? Yep, thank Leith – not for the vodka, but the lime cordial, which was invented here by Lachlan Rose in 1868. It was originally a way to ensure that sailors had enough vitamin C. Today Rose's lime cordial is still a favourite soft drink.

Ever drunk a really old Scotch? Guess what? Yes, chances are it was matured in Leith. In the nineteenth century the port had over 100 warehouses storing wine and brandy. When Europe's wine harvest collapsed in the late 1880s, most of these began storing whisky instead. There were still eighty-five bonded warehouses in Leith in the 1960s and together they matured 90 per cent of all Scotch whisky.

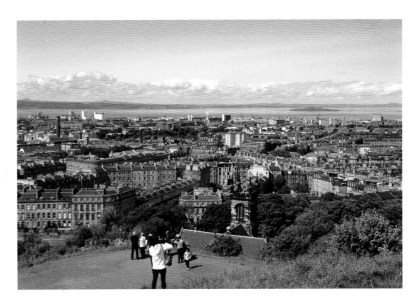

Above: Leith and Inchkeith in the firth, from Edinburgh's Calton Hill.

Below: Converted old warehouses by the quayside, new flats in the distance.

Scotland's largest lead works was founded in Leith in 1760 and was still in operation two centuries later, but has now gone. Leith also had significant locomotive works, sail makers, soap makers and rope works.

However, by far Leith's most important industry was whaling. In 1933, 37 per cent of the margarine spread on British sandwiches was made with whale oil, and the vast majority of that oil came from whales caught by ships of the Christian Salvesen company, which was based in Leith. Salvesen was a Norwegian who moved to Scotland and set up a shipping company in Leith in 1872. By the turn of the century his sons had diversified the business into whaling. They had bases in the Arctic and later the Antarctic. Leith Harbour, in South Georgia, was named after the company's Scottish home. This became the busiest whaling station in the world: between 1909 and 1965 it processed 48,000 whales. In good years Christian Salvesen saw 100 per cent dividend on their investment, and at the peak of the business in the 1920s the company made the equivalent in today's money of £100 million a year in profit. Whaling is frowned upon these days, but the company is still going strong as a transport and logistics operation, although it is no longer based in Scotland. Leith whaling ships brought the very first penguins to Edinburgh Zoo around 1900.

One wharf crumbles, another is piled with ores.

Regeneration

Leith's shipyards, docks and heavy industry all declined severely after the Second World War. Leith once had five passenger railway stations and six goods stations; by 1972 all but one goods station had closed. The once grand Central Station became a derelict shell haunted by heroin addicts. This sad symbol of 1980s Leith was made famous by *Trainspotting* author Irvine Welsh.

However, like many UK dockland areas, Leith has been transformed from a grimy industrial port to a coastal leisure destination, with swish bars and Michelin-starred restaurants

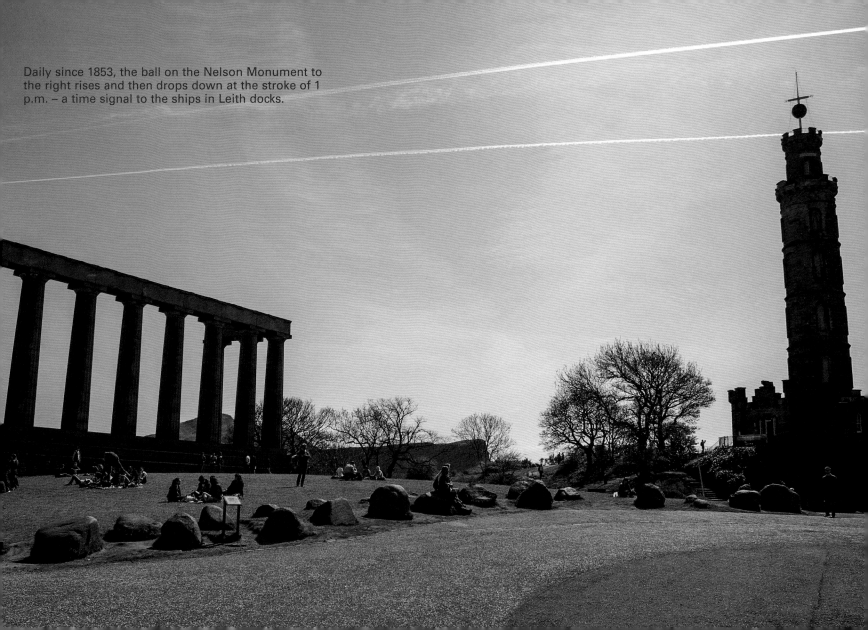

Daily since 1853, the ball on the Nelson Monument to the right rises and then drops down at the stroke of 1 p.m. – a time signal to the ships in Leith docks.

frequented by workers from the local design studios, software houses and government offices. Here is a personal illustration of the change: I remember as a small boy being driven through Leith by my father. He was employed as a builder then and had a hardworking man's physique and a Judo black belt in his wardrobe; not a man to be easily intimidated. We went along an old quayside with tatty houses to the left and decrepit warehouses on the far side, and took a right turn over a small and slightly arching bridge. The water looked grim. The few straggly characters shifting from foot to foot by the parapet looked even grimmer. A few more yards further on we passed a lone building on our left, a pub called the Black Swan. 'Ah, the mucky duck,' my father mused. 'Son,' he said with his eyebrows lowering heavily, 'never, ever, go in that pub.' The awed tremble in his voice made me vow that I never would. Today that pub is a bright teahouse called Roseleaf, packed out with Scottish Government workers at lunchtimes and advertising creatives thinking up the next Irn Bru ads in the afternoon.

That said, Leith is a big place and a part of it is still a working dock – the largest enclosed deepwater port in Scotland in fact. Every year boats arrive with over a million tonnes of coal, ores, timber, pipes, animal feeds and metals. Sailors tumble into the pubs and ladies (and gentlemen) of negotiable affection wander along the quieter streets after nightfall. The port also has berths for cruise ships, with forty vessels and 20,000 passengers using Leith as a gateway to Edinburgh and Scotland.

The name's Pond, James Pond.

Portobello

It was the Ibiza of its day – when the sun came out, the holidaymakers swarmed in their hordes to Portobello, Edinburgh's seaside resort.

Portobello lies 3 miles outside Edinburgh and was very much a wild place in the early eighteenth century, haunted by smugglers and backed by impenetrable thickets of gorse. In 1742 a sailor called George Hamilton built himself a cottage in the emptiness (at what is now the junction of the High Street and Brighton Place) and called it 'Portobello Hut' – Hamilton had been present at the Navy's capture of Porto Bello in Panama. It was still just a gusty

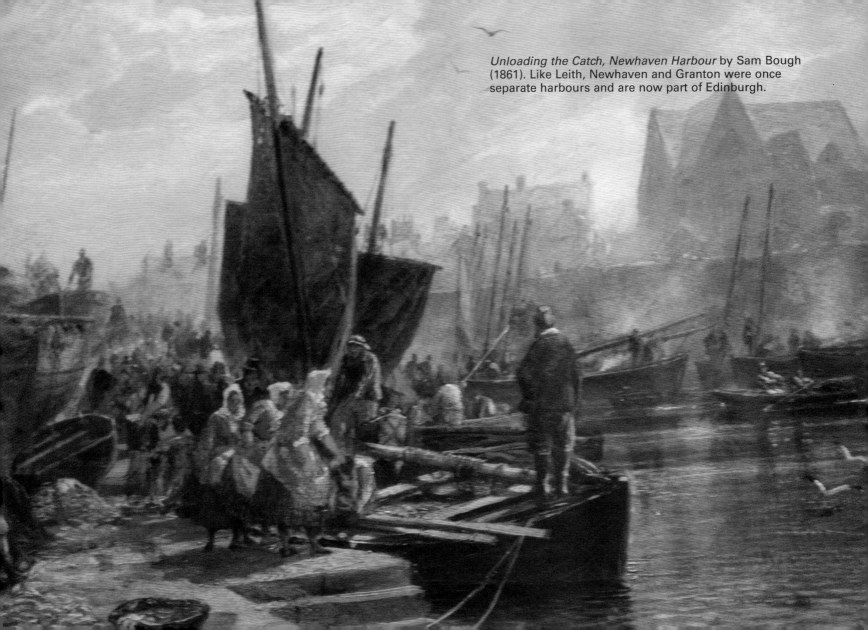

Unloading the Catch, Newhaven Harbour by Sam Bough (1861). Like Leith, Newhaven and Granton were once separate harbours and are now part of Edinburgh.

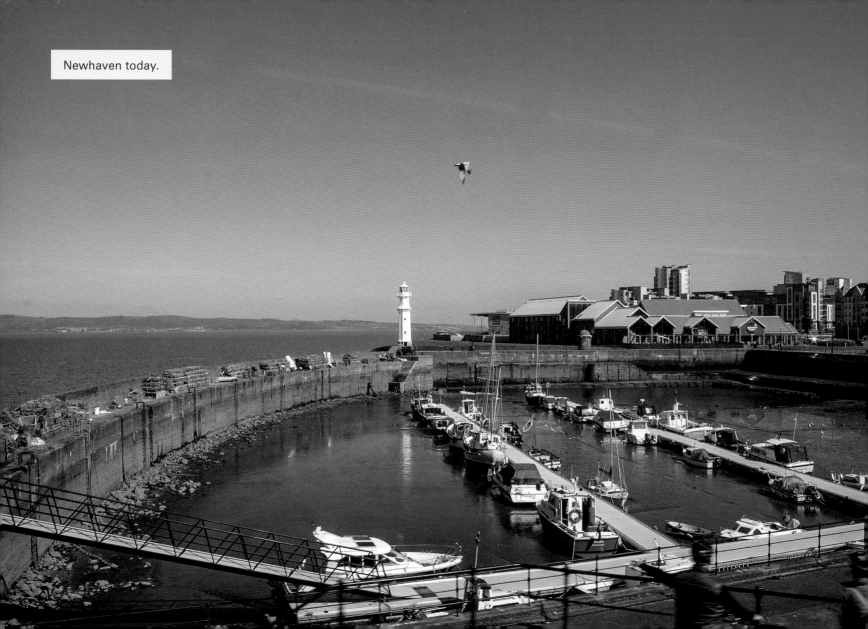

Newhaven today.

stretch of sand in 1745 when Bonnie Prince Charlie reviewed his highland Jacobite army after it had routed Sir John Cope's government troops at the Battle of Prestonpans.

However, an abundance of local clay led to the founding of a pottery works, and the town grew rapidly. Sir Walter Scott finished writing his famous narrative poem 'The Lay of the Last Minstrel' here in 1805, while lying in bed recovering after being kicked by a horse on the beach.

In the Victorian era it became a thriving resort. Throughout the summer season visitors would arrive by special train or steamer and proceed down to the marvellous new promenade to take in the view and explore the amusements. They could stroll along the 1,250-foot-long pier, designed by our old friend Sir Thomas Bouch (*see* chapter 5), to dine at the restaurant or admire the observatory at the end. The beach would be absolutely packed – although there would be no flesh on show!

In the early twentieth century, Portobello gained further attractions. The Marine Gardens had a theatre, a ballroom, a scenic railway and a speedway track. Indoor baths opened in 1901, followed by a beautiful art-deco outdoor swimming pool in 1936. This had diving boards and the first wave machine in Scotland. It was supposedly heated by the power station next door, although my five-year-old self would have told you that was a brutal lie! As a lad, Sean Connery spent several seasons working here as a lifeguard. The young Bond probably had no trouble sorting out runners, bombers and petters.

The cheap overseas package holidays of the 1960s and 1970s did for Portobello, and by the 1980s it was a sad place with a dirty beach, old-man pubs and rather threatening amusement arcades. The Marine Gardens, the outdoor pool, the power station and the pier are all long gone.

Today there are still two small amusement arcades, but Porty has reinvented itself as a sought-after suburb, particularly for young families. The beach is clean, there are decent shops and attractive cafes and bars.

Portobello Pier opened in 1871 to great acclaim, but fell into ruin and was demolished in 1917.

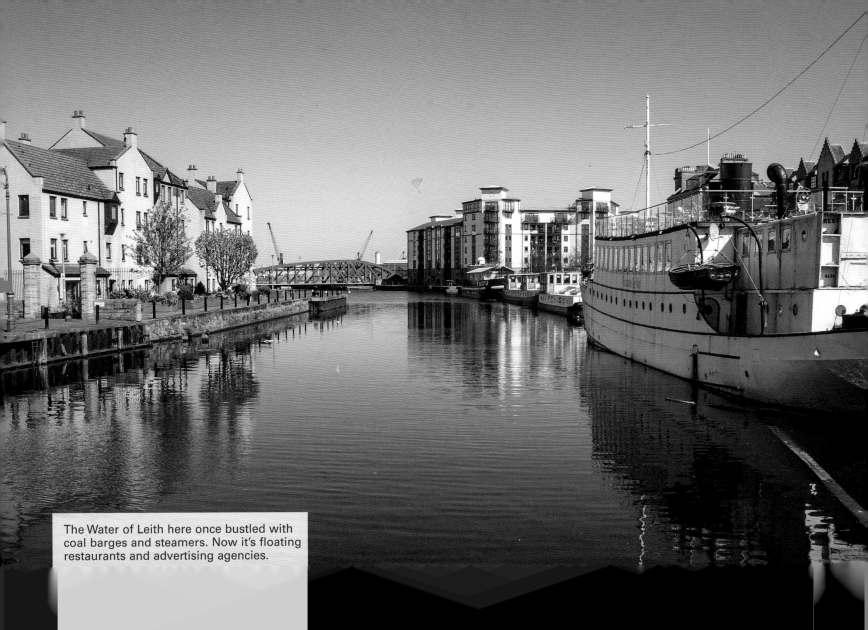

The Water of Leith here once bustled with coal barges and steamers. Now it's floating restaurants and advertising agencies.

8

OUTER FIRTH SOUTH

Sunset in East Lothian.

Leaving Portobello we pass through Joppa, once a major salt-panning centre, and into the ancient town of Musselburgh. The Romans were the first to spot the delights of this little corner of the world, building a fort here and the first bridge over the River Esk.

Musselburgh is known as 'The Honest Toun', and celebrates this by the annual election of the Honest Lad and Lass. The story goes that the when the Regent of Scotland, Randolph, Earl of Moray, fell ill here in 1322, the local citizens went to great lenghts to care for him. When he died, the new regent, the Earl of Mar, offered to reward the people for their loyalty but they declined, saying they were only doing their duty. The earl was impressed and said they were a set of honest men, hence 'Honest Toun'. To the east of the town is one of the UK's most stylish racecourses. The course was officially founded in 1816, but races were held here long before that. Golf has been played on the course in the middle of the racetrack since at least 1672. The Royal Musselburgh Golf Club is the fifth-oldest golf club in the world, although its 'Old Club Cup' was first

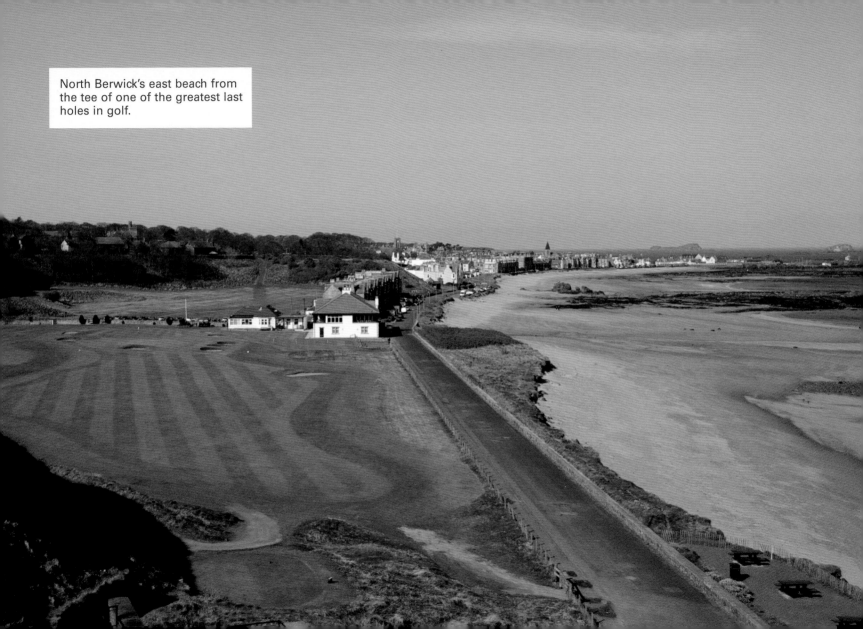

North Berwick's east beach from the tee of one of the greatest last holes in golf.

The shores of the outer firth are dotted with tiny harbours.

played for in 1774 and is the world's oldest golf trophy that has been continuously competed for. It is on display in the clubhouse.

As its name suggests, Prestonpans was once a salt-panning centre. By the beginning of the fifteenth century there were ten salt works here, producing 800–900 bushels of salt per week. Monks began mining coal here in 1210; this was probably the first coal mine in Britain and the industry continued at Prestonpans for centuries. Mining and panning being very thirsty work, Prestonpans also had sixteen breweries. The Battle of Prestonpans on 21 September 1745 (also known as the Battle of Gladsmuir) was the first major conflict in the second Jacobite rising. Bonnie Prince Charlie's army walloped the forces of George II, led by Sir John Cope. With their tails now well and truly up, the Jacobite forces marched south, eventually making it as far as Derby, just 125 miles (200 km) from London. However, Charlie got carried away with his own fancies, believing that no army would dare to march against the 'true prince'. He ignored sound military advice and was forced to retreat. His army was slaughtered at Culloden the following year. Charlie escaped to France dressed as a girl and that was that for the Jacobites.

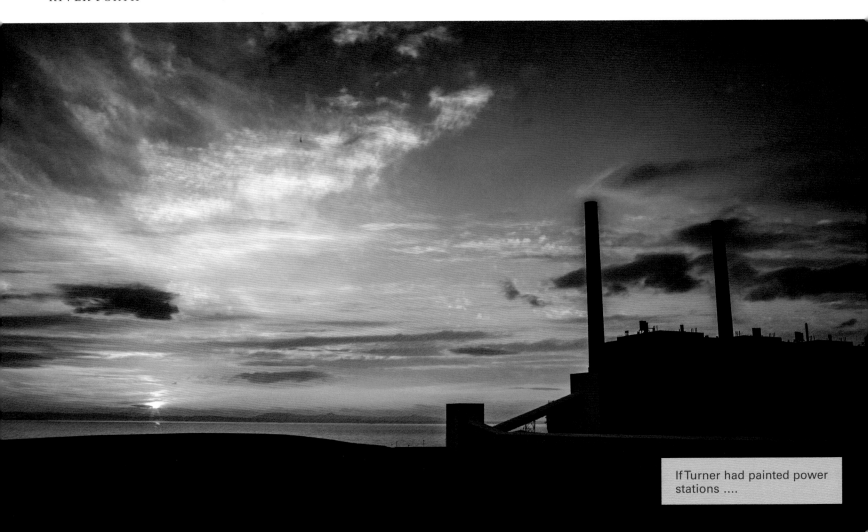

If Turner had painted power stations

Cockenzie and Port Seton were originally a pair of tiny fishing villages. Some boats still bring catches of prawns and fish back to Port Seton. To most people today, Cockenzie is known for its enormous twin-chimneyed power station, a landmark throughout the whole outer firth area.

Just outside Longniddry is Gosford House, a grand neoclassical stately home originally planned by Robert Adam. From here we start on stretch of country that has golfers going weak at the knees. Rivalled only by the Fife coast on the other side of the firth, the next few miles have some truly outstanding courses: Longniddry itself, Craigielaw, Archerfield, Kilspindie, North Berwick (two courses) and Gullane, which has five top courses, including the Open venue Muirfield.

North Berwick

There has been a harbour here since the twelfth century, and for the next 500 years you could catch a ferry over the Firth of Forth to Earlsferry in Fife. Today the harbour is filled with yachts and pleasure boats. North Berwick somehow managed to retain its branch line amid the Beeching cuts of the 1960s, which has helped to keep the town's heart beating. Other nearby places that lost their lines, such as Gullane and Haddington, are noticeably less vibrant.

Robert Louis Stevenson spent many a happy summer holiday here (as did I), and the gnarly island of Fidra, just to the west, was his original inspiration for *Treasure Island*. He also set parts of his novel *Catriona* in this part of the world.

Muirfield has hosted the Open sixteen times, including in 2013. The Forth and Edinburgh lie in the distance.

Just inland from North Berwick is East Fortune, home to the National Museum of Flight and a popular airshow.

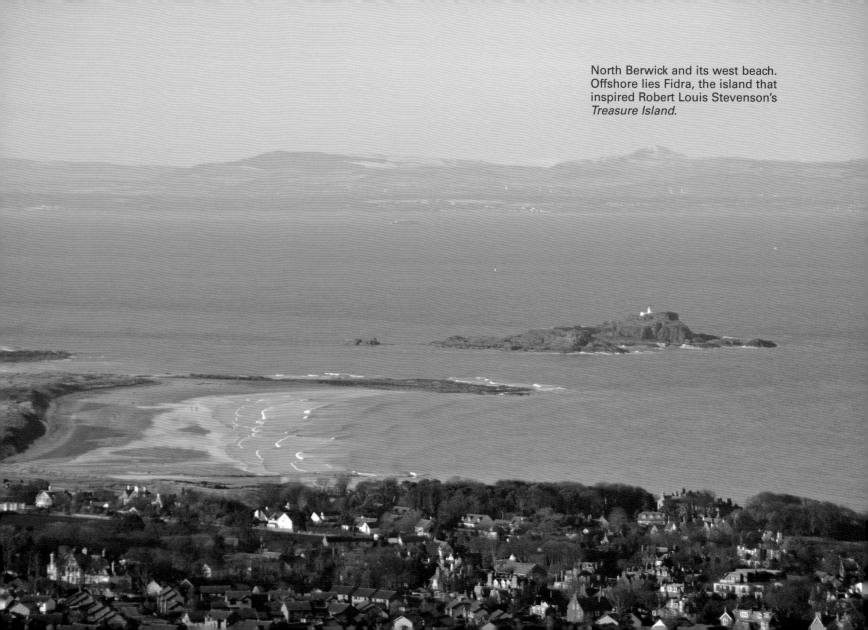

North Berwick and its west beach.
Offshore lies Fidra, the island that
inspired Robert Louis Stevenson's
Treasure Island.

The sun sets over Aberlady bay.

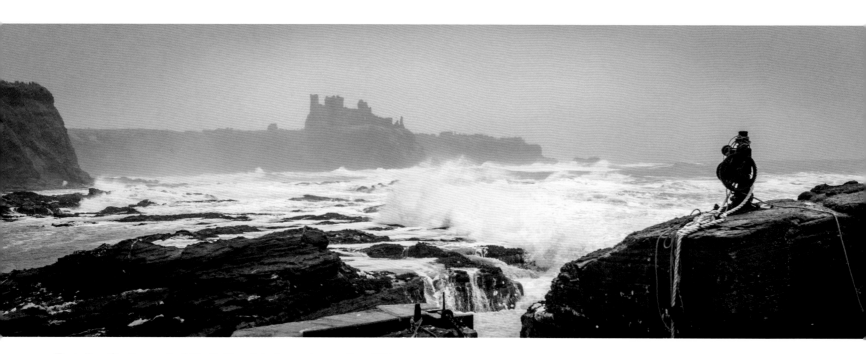

Tantallon Castle, east of North Berwick, from stormy Seacliff beach.

9

THE ISLANDS

The tide recedes and the fun starts – Cramond Island.

Cramond Island

Seen from the side, Cramond Island seems to be connected to the mainland by a zip. But these 'teeth' are actually concrete pylons installed in the Second World War to stop submarines from sneaking through to the naval base at Rosyth and the vital Forth Bridge. Cramond Island is one of forty-three tidal islands in Britain (there are seventeen in Scotland) and it is an easy mile-long walk out to it along a paved causeway. This should only be attempted during the two hours either side of low water – the tide fairly races in over the flat sands, as your author's twelve-year-old self could attest. Despite tide tables being posted on the shore alongside huge warning signs, every year some bonehead manages to get themselves stranded.

The island was used as a sheep farm for centuries. The now-ruined farmstead on the island was inhabited until the 1930s and sheep were still being kept on the island in the 1960s. Like the other

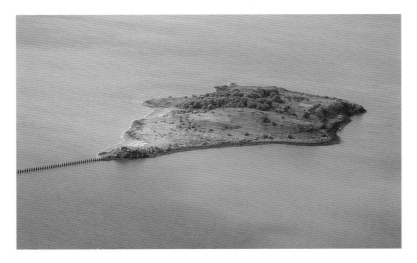

islands in the Firth of Forth, it was fortified when war broke out in 1939. The squat, concrete buildings you see as soon as you cross the causeway once held a 75 millimetre gun and its accompanying searchlight. There are more old gun emplacements on the north coast, as well as storehouses, shelters, two engine rooms and the remains of a barracks.

Inchmickery

It may look like a battleship, but Inchmickery's job was to blow them out of the water. This tiny island (just 328 feet by 656 feet) bristles with gun emplacements built during both world wars. The island is now an RSPB reserve, where common eider, sandwich terns and various gulls come to breed. The very rare roseate tern also used to nest here – they moved to Long Craig Island, a tiny lump of rock that few people know about because it is situated directly under the Forth Road Bridge. Rather a noisy place to set up home, one would imagine. Inchmickery was also once famous for its oyster beds. Best not to eat any shellfish you find here now.

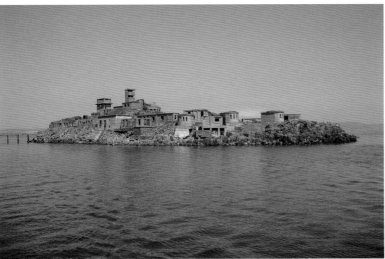

Above: Cramond Island from the air.

Below: Inchmickery sets sail.

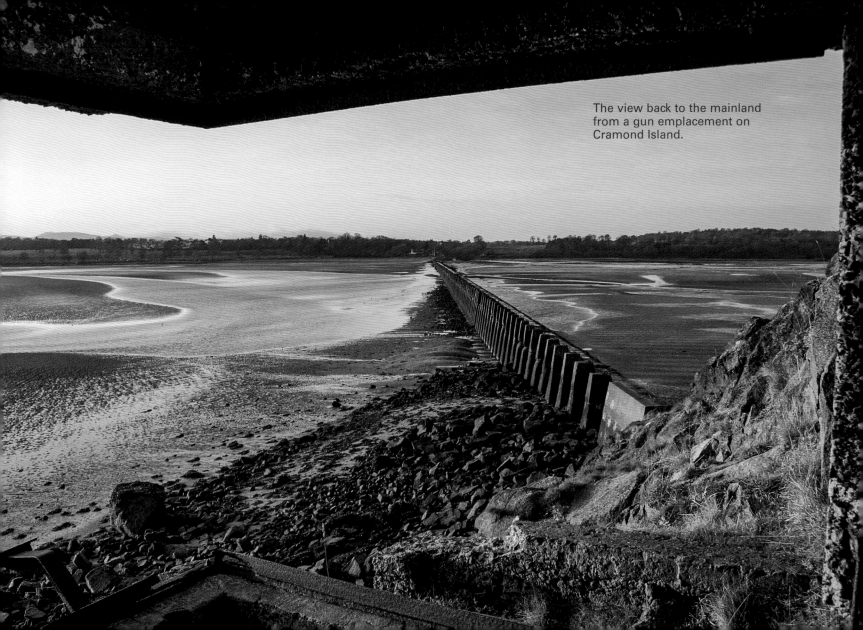

The view back to the mainland from a gun emplacement on Cramond Island.

Inchcolm

There isn't a more perfect monastic house in Scotland, but Inchcolm's Augustinian abbey has to be one of the least visited of the country's historical treasures. Which makes a trip out there on the boat from South Queensferry all the more exciting.

Inchkeith

It has been a colony for plague victims, a cattle farm, a training ground for royal hawks, a military garrison and an English base for attacking Scotland. Yes, Inchkeith has seen more intrigue and adventure on its 56 acres than many islands. It was also the setting for one of the most extraordinary experiments in the history of science. In 1493, King James IV ordered that a woman and two babies be taken to the island to live there in total isolation from the rest of the world. This was odd enough, but the truly strange part was that the woman was completely mute. The aim of the experiment was to show which language the infants would 'naturally' grow up speaking – it would discover humankind's 'original' language, or language of the gods. When observers went back years later, they found that the infants did not speak at all.

The island also has its share of gun emplacements, and Inchkeith played a major role in defending the waterway during both world

Some firth wildlife not being very wild.

wars. There were up to 900 soldiers crowded together on this rocky isle, and together the estuary's islands were known as 'Fortress Forth'.

The island's splendid lighthouse was manned until 1986, but is now automated. The Northern Lighthouse Board sold the island to the millionaire founder of Kwik-Fit, Sir Tom Farmer, who still owns it today.

Inchkeith is also officially the driest place in Scotland, with an average annual rainfall of just 21.7 inches. The wettest place, in

case you're wondering, is Dalness in Glen Etive, with 130.16 inches of rainfall.

Isle of May

The low-lying rocky rump you can see out in the firth from Fife's East Neuk is the Isle of May, the UK's number one puffin hotspot. Seals sit loafing on the rocks all year round and whales often splash by. Boat trips run out to the island in the summer from Anstruther.

Bass Rock

> ... just the one crag of rock, as everybody knows, but great enough to carve a city from.

So wrote Robert Louis Stevenson, who had the rugged romance of the Bass Rock imprinted on his brain during childhood holidays in North Berwick. He set part of his novel *Catriona* on the Bass.

The 351-foot rock sits at the very limit of what could be termed the Firth of Forth and to centuries of voyagers it has served as an

Above: Approaching Inchcolm.

Below: View from the abbey on Inchcolm.

unmistakeable marker to this vital waterway. With its lighthouse automated, the rock is today uninhabited, but it has been home to many different types of people over the years. St Baldred, a Christian hermit, moved into a cell here in AD 600 and the small ruined chapel on the Bass is named after him. A prison was later built on the rock and James I took particular delight in consigning his enemies to a lonely doom here. There is also a small castle perched on the very edge of the crags below the lighthouse.

If you've ever wondered why the Bass looks white even though it's an enormous volcanic rock, you can thank the 150,000 gannets who call it home. As it is the largest single rock gannetry in the world, it looks white from the mainland due to the sheer number of birds – and their droppings – on the ground. You can take a boat ride out to the Bass from North Berwick, and it's an exhilarating experience to see the whole sky above you filled with wheeling, screeching seabirds. Make sure you wear a hat and waterproofs …

If you don't fancy being a target for avian poo-bombers, you can watch all the action from the comfort of the Scottish Seabird Centre in North Berwick. Their solar-powered cameras beam back live images of the birds to large screens. The images are so sharp that you can read the ID rings on birds' feet. And, presumably, see exactly what a mountain of poo looks like close up.

One of the best views of the Bass is to be had from the top of North Berwick Law. This volcanic hill offers a panoramic view over the town below, as far as St Abb's Head, on the Lammermuir hillside, Traprain Law and Garleton hills backing onto the Moorfoots and Pentlands, then the Forth, the Ochils and Grampians with East Neuk of Fife on the north shore of the firth.

Climb it. Go on, it will be worth it, I promise. Aside from the lovely view of the town, the firth and its islands, it is a little-known fact that at the top of North Berwick Law you can see into the future. For here, if the weather is fine – which it so often is in this part of the world – and your eyes are keen or young (or both, God bless you), then you will be able to see all the way to Ben Lomond, a rocky knuckle on the horizon, where our journey began. And the rain that is falling there (for it is measurably not so fair a place as the one in which you now stand) will, in some weeks hence, flow past the sulking Bass at your feet.

That view west, then, is the future of the Forth. The sea to the east is its past. And you now stand above it all, in this moment that the two ripple together on the tide – the present. When, I sincerely hope, you are happy.

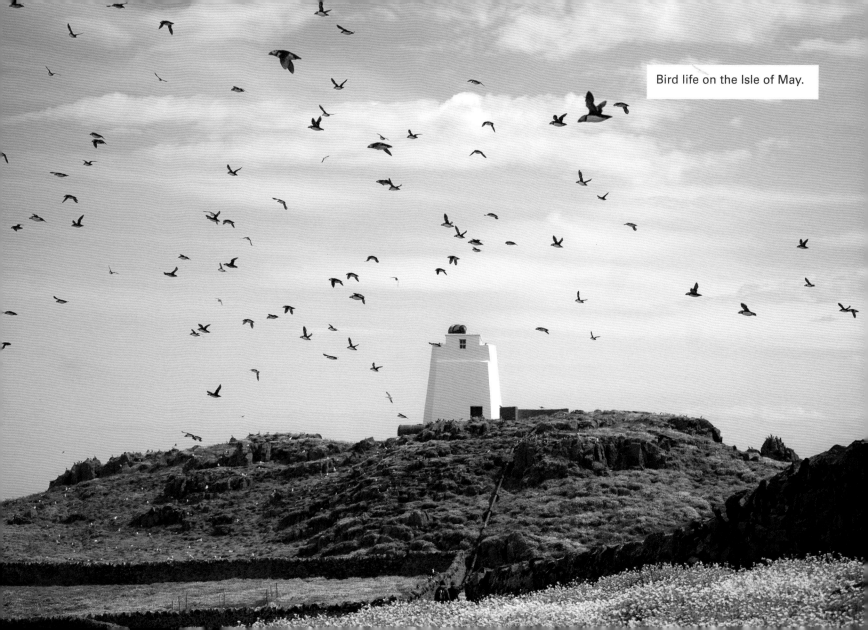

Bird life on the Isle of May.

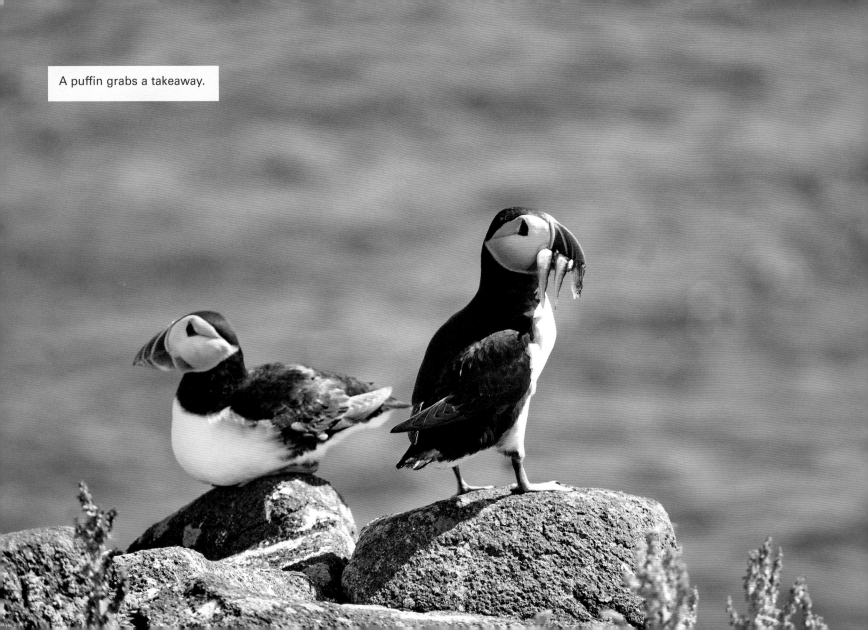

A puffin grabs a takeaway.

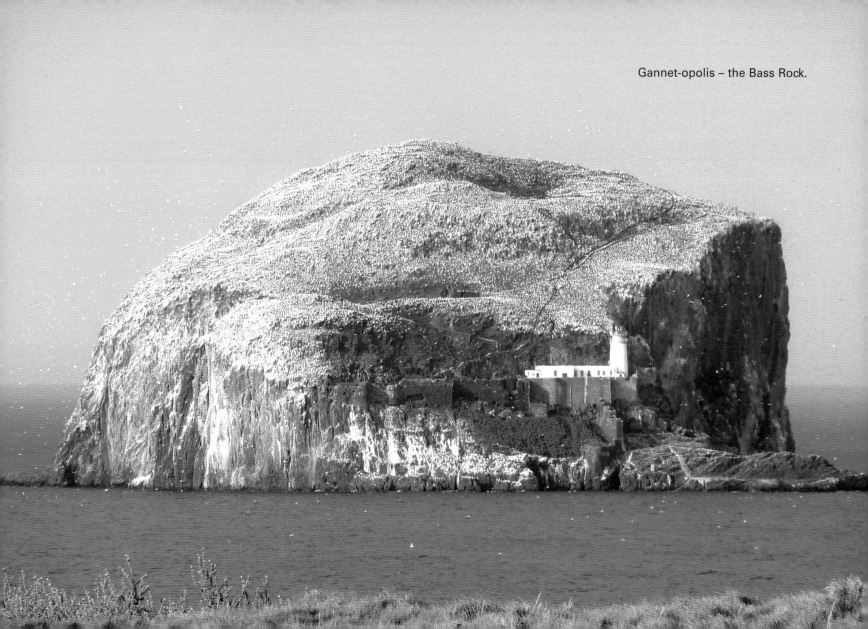

Gannet-opolis – the Bass Rock.

Bye! Edinburgh and the Firth of
Forth from a hundred miles out ...

PHOTOGRAPHY CREDITS

All photographs © Mark Steward except for those on pages 61, 62 (top), 63, 64, 70, 71 (all), 74, 75, 76, 77, 78 (both), 80, 81, 82, 83 (both), 84, 85, 86, 87, 88, 89, 92 (both), 110 (top), 112, 127, 129, 130 (top right & bottom right), 131 (both), 132, 133, 136, 138, 149, and 151 which are © Richard Happer. Photographs on pages 33 © Deanston Distillery, 67 © Harry Happer, 100 © Annalie Mary, 101 © The Scotsman Publications Ltd, 105 (bottom) © Peter Stubbs: edinphoto.org.uk, 134, 137 © Valentine of Dundee, 139, 141, 142, 143, 144, 146–147, 148 © Craig Muir: craigmuir.co.uk, 158 © Josie Anne. Painting on page 121 © William Dow.

We are also grateful to the following individuals and organisations for making the images on the noted pages available under Creative Commons Licence 2.0 (unless otherwise stated): 6, 8 Flickr user John McSporran, 10–11 Flickr user John McSporran, 17 (left) Flickr user John McSporran, 18 (top) Alan Weir via Wikipedia, 25 Flickr user Nick Bramhall, 26 Flickr user Stuart Gordon, 28–29 Flickr user Ian Dick, 32 (top) Jaime González, 36 (bottom) Flickr user Magnus Hagdorn, 41 (top) National Library of Scotland via Wikipedia, 42 (both) Flickr user dun_deagh, 43 (top) Stirling Council/John McPake via Flickr, 43 (bottom), 50 Kim Traynor via Wikipedia, 52 Flickr user Shadowgate, 53 Flickr user Derek Scott, 54 Stirling Council/John McPake via Flickr, 56 Flickr user Gary_Denham, 57 Flickr user Chris_Hills, 59 Flickr user Oliver Townend, 62 (bottom) Stirling Council, 65 Flickr user Aaron Bradley, 72 (left) Flickr user John Johnston (right) Flickr user Valerie Wilson S, 79 Kim Traynor via Wikipedia, 91 (top) Flickr user 4652 Paces (bottom) Kim Traynor via Wikipedia, 93 (top) Phillip Capper via Wikipedia (bottom) Flickr user Alasdair, 95 (left) Mark Owens/MOD (right) Kim Traynor via Wikipedia, 96, 97 Open Government Licence, 98–99 George Gastin via Wikipedia, 102 Flickr user pathless, 105 (top) Flickr user Dave Conner, 106 Transport Scotland/Open Government Licence, 107 Flickr user Chris Combe, 108 (both) Public Domain, 109 Flickr

user Andy Roberts, 110 (bottom) Flickr user andrum99, 111 Madir via Wikipedia, 113 Flickr user sonder3, 117 Andy Hawkins via Wikimedia, 118 (top) Flickr user Katherine, 130 (top left) Tim Felce (Airwolfhound) via Wikipedia, 135 Stephencdickson via Wikipedia, 140, 145 Flickr user easylocum, 150 (top) Mtcv via Wikipedia (bottom) Veedar via Wikipedia, 152 Flickr user 4652 Paces, 153 (top) Flickr user Magnus Hagdorn (bottom) Flickr user Andy Hawkins, 155, 156 Flickr user Scott Presly, 157 Honge (talk) via Wikipedia.

Cover design by Mark Steward at pixocreative.com

Front-cover photo by Flickr user Chris Combe.
Back-cover photo by Mark Steward.